Any Day Now

David Zwirner Books

ekphrasis

Any Day Now: Toward a Black Aesthetic
Larry Neal

Selected and introduced by Allie Biswas

Contents

Editor's Note

The essays by Larry Neal that make up this volume were first printed between 1964 and 1976 across various publications. The original publication information is indicated on the first page of each text. In order to respect the integrity of Neal's original writing, we have made minor interventions only to correct typos and to standardize spellings and punctuation for greater consistency and readability. The majority of Neal's original texts capitalize the word "Black," and as such we have made this style consistent throughout the volume, save for passages in which Neal quotes from other writers. To follow Neal's predominant usage, we have also lowercased instances of "white." We have maintained his capitalization of terms where the choice was clearly deliberate, particularly in the 1968 editorial in *The Cricket*.

Introduction

Allie Biswas

In August 1969, Larry Neal's seminal essay "Any Day Now: Black Art and Black Liberation" was featured in an issue of *Ebony* magazine dedicated to the Black Revolution. In it, he defined the principles of a social and cultural movement that had been gaining momentum since the beginning of the decade and which had intensified by the end of the 1960s. The primary objective of the Black Arts Movement, Neal wrote, was "to link, in a highly conscious manner, art and politics in order to assist in the liberation of Black people."[1] Art was intrinsic to this mission, because, as he stated, "if we assert that Black people are fighting for liberation, then everything that we are about, as people, somehow relates to it."[2] As a highly influential critic, Neal played a major role in the development of the Black Arts Movement in the 1960s and 1970s, writing articles on literature, drama, and music, as well as the social and political climate of the day.

Aligned with the politics of Black Power, which advocated for self-definition and self-sufficiency, the Black Arts Movement was equally propelled by the prospect of liberation: "The Black Arts and the Black Power concept both relate broadly to the Afro-American's desire for self-determination and nationhood," Neal wrote. "One is concerned with the relationship between art and politics; the other with the art of politics."[3] Neal, along with writers including Amiri Baraka, Askia Touré, Ishmael Reed, Samella Lewis, and Don L. Lee (later known as Haki Madhubuti), was dedicated to a cultural revolution in art and ideas, calling for a new type of artwork that responds to Black American history and that "posits

for us the Vision of a Liberated Future." He continued: "Make a form that uses the Soul Force of Black culture, its lifestyles, its rhythms, its energy, and direct that form toward the liberation of Black people."[4] The essays collected in this volume, including "Any Day Now" and his 1968 text "The Black Arts Movement," which served as the movement's manifesto, explore Neal's central idea that a Black aesthetic must address the spiritual and cultural needs of Black America.

Neal moved to New York shortly before the Harlem race riot of July 1964 and quickly became a luminary of the Black arts scene in Manhattan. He had recently completed graduate courses in folklore at the University of Pennsylvania and briefly taught English literature at Drexel Institute of Technology. As an undergraduate at Lincoln, a historically Black university, he became drawn to a special collection of books that allowed him to study Black American histories, specifically folk traditions and mythologies, as well as customs relating to street chants and slang. He was also politically engaged, and while working in a bookstore in graduate school, he came across a magazine published in Paris that highlighted liberation movements in developing nations, titled *Revolution: Africa, Latin America and Asia*. Through this publication, Neal first encountered the writing of Amiri Baraka (who previously published under the name LeRoi Jones) and A. B. Spellman—the three authors would later establish a music magazine called *The*

Cricket: Black Music in Evolution. Revolution situated Black Americans in the context of anticolonial movements in Africa, prompting Neal to later reflect, "This was really a revelation.... Right away bells started going off because there were people thinking the same things."[5]

Around the same time, Neal also encountered Jan-heinz Jahn's book *Muntu: An Outline of the New African Culture*, published in 1961. It proposed that art, as it existed in various African cultures, was an entity based in rhythm and spiritual energy. Neal had already been discussing such ideas among an informal group of writers and artists—including the playwright Charles Fuller and the artist James T. Stewart (Neal's friends from childhood who were integral to the Black Arts Movement)—in Philadelphia, a city that held substantial currency in the growing Black liberation movement. *Muntu* proved to be a breakthrough for them, offering a way in which to think about the ties between Black American culture and the continent. Neal later wrote, "We were coming out, as you might recall, in American literature, of the so-called beat generation.... We felt a certain distance between us and that strictly literary approach to working. That is to say, an enclosed literary context. We were looking at the world as young Black people and saying, 'Where does that fit with reference to where we are, because we see ourselves at a certain point involved in struggle.' ... *Muntu* opened up the question of how poetry readings and drama can be dynamic, and dynamic in Afro-American terms, terms that we felt comfortable with."[6]

From his base in upper Manhattan, Neal contributed to several of the critical journals that had been established in the 1960s to serve as a "meeting place" for Black people anywhere, as the periodical *Black Dialogue* put it—a sentiment that made reference to liberation initiatives outside the United States. These largely independent journals were distributed nationally and were intrinsic to how the Black Arts Movement was able to formulate itself within the public realm. Neal's insights could be found in such publications as *Negro Digest* (later renamed *Black World*), though his writing also occasionally appeared in *The New York Times* and *Performance*. His most important appointment was as a staff writer at *Liberator*, beginning in October 1964, after which he served as arts editor, from January to August 1966. As editor, Neal ensured that coverage of the arts became a central component of the magazine, and he signaled this intention in the January 1966 issue with his essays "The Development of LeRoi Jones" and "The Black Writer's Role: Ralph Ellison," as well as criticism by Baraka and Touré, a writer at *Liberator* who had recruited Neal to the magazine.

Liberator was founded in New York by Daniel H. Watts in direct response to the assassination of Patrice Lumumba, the first prime minister of the Democratic Republic of the Congo, in January 1961. In February, Watts joined protesters in front of the United Nations building in New York in the claim that the American government was complicit in Lumumba's death. The first issue of *Liberator* followed in March. The magazine was consid-

ered uncompromising in its political remit, aligning itself with burgeoning anticolonial movements around the world. Specifically, it advocated for independence initiatives developing across Africa. Moreover, the publication was conscious of setting an editorial agenda that would persuade its readers of the alliance between Black Americans and Black people in other countries, in turn prescribing to the unity upheld by Pan-Africanism.

Beginning in the early 1960s, the politics of assimilation advanced by Martin Luther King Jr. had, for many, been overshadowed by the powerful words of Malcolm X. "I can't recall when I first heard Malcolm speak. But the nature of my life, its style and rhythm, has been altered in ways unnamable ever since," read the opening of Neal's 1966 text "Malcolm and the Conscience of Black America" in *Liberator*. While Malcolm X's nationalist philosophy reiterated ideas put forth by earlier political leaders, namely W. E. B. DuBois and Marcus Garvey, his hard-hitting approach was unprecedented. "Civil rights and brotherhood were in vogue when Malcolm started 'blowing'—started telling the truth in a manner only a deaf man would ignore," Neal wrote, adding, "Many of us *were* deaf, or if not, in a deep sleep."[7] In Malcolm X's tackling of the "psychological barriers which have kept Black people in a semi-colonized condition," Neal realized that "Malcolm's stance as a Black man was *itself* a program."[8] Equally important to Neal was Malcolm X's presence as a poet. He came from the "tough tradition of the urban street speaker," but there was "a distinct art

in his speeches, an interior logic that was highly compelling and resonant."[9] By the end of the decade, following Malcolm X's assassination in February 1965 at the Audubon Ballroom in New York, which Neal witnessed, his influence had not weakened. The problem, Neal agreed with Malcolm X, had ceased to be one of civil rights; it was now a problem of human rights. "It always seemed to me that he was talking about a revolution of the psyche, about how we should see ourselves in the world."[10]

Neal often made reference to the sensation of a "double consciousness," defined by W. E. B. DuBois in his 1897 essay "Strivings of the Negro People" as "this sense of always looking at one's self through the eyes of others, of measuring one's soul by the tape of a world that looks on in amused contempt and pity. One ever feels his twoness,—an American, a Negro; two souls, two thoughts, two unreconciled strivings."[11] As Neal saw it, a Black aesthetic, which would allow this split self to be cast aside, could be fully realized only if a "radical reordering of the Western cultural aesthetic" was executed.[12] The conception of art as proposed by the Western white man was "a dry assembly of dead ideas" and must be rejected, to create new values and new ways of living in its place.[13] The point relates to the importance Neal placed on self-definition, which was at the center of the ideology that governed his thinking.

Malcolm X's assassination, as Baraka later related, prompted many of his peers to "pull away from the bourgeois rubric that art and politics were separate and ex-

clusive entities."[14] Three months later, Neal and Baraka, along with Touré, opened the Black Arts Repertory Theatre School (BARTS) in Harlem, directly in response. Establishing this organization was a conscious attempt to create a union between art and politics in the heart of the Black community, offering a space for Black writers to stage their ideas and for young people to have access to educational initiatives. Although it operated for just under a year, the theater launched the Black Arts Movement, serving as a cornerstone of its early development. The theater's arrival was celebrated with a series of readings by poets who included David Henderson, Calvin Hernton, and Ishmael Reed, which Neal covered in his announcement of the momentous occasion in a *Liberator* article called "The Cultural Front."

Among Neal's earliest assignments for *Liberator*, in February 1965, was a review of two plays, *The Slave* and *The Toilet*, by Baraka, which he described as "attempts to break down the barriers separating the artist from the audience to whom a work must ultimately address itself." A four-part series on contemporary literature soon followed, focusing on the novelists Richard Wright, Ralph Ellison, and James Baldwin. This was especially important in putting forward some of the inquiries that were essential to Neal's thinking. "What is the role of the Black writer in these intense political times," he asked. "This society must be changed. The writer must be a part of that change. He must be the conscience and spirit of

that change."[15] In the culminating text of the series, "The Black Writer's Role," Neal penned his most forceful and memorable treatise. "Black writers must listen to the world with their whole selves—their entire bodies," he wrote. "Must make literature *move* people. Must want to make our people *feel*, the way our music makes them feel. Feel the roots of their suffering and pain and come to understand *all* of the things that they must *do* about it." Those who earnestly engaged with Black American traditions in order to excavate new possibilities, as Ralph Ellison and Zora Neale Hurston did, were consequently on to something. "Ellison is probably a walking repository of Afro-American myth, folklore, rhymes, and blues," Neal wrote.[16] Similarly, Hurston held Neal's attention as one of the first Black writers to embrace Black folklore, through her studies of the cultures of the rural South and of voodoo practices in Haiti and Jamaica. (He was instrumental in bringing her autobiography, *Dust Tracks on a Road*, back into print in the 1970s, and wrote the introduction to the new edition.)

But Neal became bothered by what he believed was a limitation. Were writers able to achieve "affective contact" with their readers? Could prose create unity between the artist and the audience? "The novel is a passive form," he continued in "The Black Writer's Role," adding that it is "not conducive to the kind of social engagement that Black America requires at this time.... The real revolution in Black literature is occurring among the poets and dramatists." The effect of music,

drama, and poetry carried significant weight in his arguments throughout the sixties and seventies. With such a declaration, Neal was returning to the importance of the function of art: what he described as "the sense that what is expressed is felt."[17]

A 1965 conversation with the jazz saxophonist Archie Shepp, also in *Liberator*, offered an early statement about the power of the performing arts. "The best of the New Music is a search for substance and a fundamental encounter with the social realities of America," Neal said.[18] The opening editorial of the first issue of *The Cricket: Black Music in Evolution*, in 1968, expressed this point more explicitly: "The true voices of Black Liberation have been the Black musicians.... The history of Black Music is a history of a people's attempt to define the world in their own terms."

Neal's interest in the ways in which Black culture had evolved in the United States was intrinsic to his perspectives on what art should be. Responding to a poll conducted by *Negro Digest* in early 1968, which asked writers about their values and priorities, Neal commented: "To explore the Black experience means that we do not deny the reality and the power of the slave culture; the culture that produced the blues, spirituals, folk songs, work songs, and 'jazz.' ... The models for what Black literature should be are found primarily in our folk culture.... Further models exist in the word-magic of James Brown, Wilson Pickett, Stevie Wonder, Sam Cooke, and Aretha Franklin. Have you ever heard a Black poet scream like

James Brown? I mean, we should want to have that kind of energy in our work. The kind of energy that informs the music of John Coltrane, Cecil Taylor, Albert Ayler, and Sun Ra—the modern equivalent of the ancient ritual energy. An energy that demands to be heard, and which no one can ignore."[19] Neal and his colleagues frequently made reference to Coltrane, whose music was a major catalyst for the Black Arts Movement in its pioneering of new forms that broke the foundations of Western music. In the same way, Ayler was revered for the unparalleled intensity of his sound, which Neal described as "a different and fascinating way of thinking about the world.... At his best, Albert's voices buzz and hum with awesome deities."[20] Reflecting on the poetry readings that regularly took place at the Black Arts Repertory Theatre School, Neal remarked: "They did not sound like T. S. Eliot reading his poetry. It was more in the style of the Russians, big sound, big voice, public.... Ishmael seemed to be conducting a big symphony orchestra when he read."[21] Neal and his fellow contributors at *The Cricket*, who included Stanley Crouch, Milford Graves, and Sun Ra, believed that the power of music related to its history as an art form, one that signaled a people attempting to define the world in their own terms.

Also in 1968, Neal and Baraka compiled a groundbreaking anthology of texts by Black Americans, which in many ways set the tone for contemporary Black writing. *Black Fire: An Anthology of Afro-American Writing* included more than 180 essays, poems, and short stories

by new and previously under-recognized Black authors across some 600 pages. Neal had found an ally and collaborator in Baraka. *Blues People: Negro Music in White America*, Baraka's acclaimed study on the evolution of music in the United States, published in 1963, had made a significant impact on Neal. "Here was what seemed to be a definitive statement, something that reached for the grand statement about Afro-American culture," he later declared, highlighting the value of cultural inheritance.[22] For him, the kind of art that he wanted to see flourishing in the 1960s was part of a much larger continuum. "There is no need to establish a 'Black aesthetic,'" Neal remarked in the January 1968 issue of *Negro Digest*. "Rather, it is important to understand that one already exists." He went on to mention traditions specific to the early development of an Afro-American culture, such as juju, voodoo, and the Holy Ghost of the Black Church, pointing to their ritualistic qualities. Neal published his first book of poetry, *Black Boogaloo: Notes on Black Liberation*, in 1969, which underlined his interest in vernacular speech and folklore, and in 1971, he expanded these ideas to great effect in "Some Reflections on the Black Aesthetic"—a meticulous overview which charts the various categories and elements that he believed constituted a Black aesthetic.

In the 1970s, Neal began to write his own plays. His first dramatic work, *The Glorious Monster in the Bell of the Horn*, was staged by Woodie King's New Federal Theater

in 1979 to great acclaim. "The very act of putting something in dramatic form presumes that there is an audience—outside of the artist's private one—to which a collective set of values must be conveyed," he had written fifteen years previously. "And it is in the language of a play that certain pressing ideas can best be expressed."[23] He wrote his second play, *In an Upstate Motel: A Morality Play*, in 1980, a year prior to his death.

In the last ten years of his life, Neal remained committed to the liberation of Black Americans, reiterating a belief that he had held from the beginning: a revolution without culture would result in a loss of vision, destroying the very thing that was needed in order to stay alive. Progress had been made, Neal believed, however precariously. As he contemplated in 1970, "Sometimes, in some places, it looked like we weren't gonna make it. But we squeezed through, just like we have been squeezing through for decades. Only this time there was a little more light at the end of the tunnel. . . . We were forced, as never before, to make explicit our desire to determine the nature and course of our lives. . . . What the full implications of this demand are, we do not know yet."[24]

The essays in this volume illustrate that Neal was not merely an observer in his role as a critic but at the center of a literary vanguard that determined the direction of a transforming landscape where art, politics, and culture were inseparable. His writings here are organized chronologically, in order to trace the mood of the period as the Black Arts Movement evolved, with a partic-

ularly heightened moment culminating between 1968 and 1969. The work Neal produced during these years is recognized as especially vital within his output, particularly in the context of the influence it carried. Relatedly, the sixteen texts that have been selected chart Neal's own path, beginning with a poem and one of his earliest commentaries in 1964 for *Liberator* and ending in 1971 with a comprehensive proposal for what a Black Aesthetic might entail. He remained prolific, though, right until the end of his life, continuing to publish the kind of authoritative essays for which he had become revered. Similarly, other writers endured as critical subjects for Neal, highlighted here by the texts on Baraka and Hurston, which, typical to his approach, bring awareness to the achievements of each author. His presence was distinct. As Baraka observed, Neal was "hot and brightly shining. Full of life"; a "sophisticated, aristocratic, talented, and complex individual," according to Ishmael Reed.[25] To Stanley Crouch, he was "one of the most adventurous and intelligent men we had."[26] In a voice that was urgent, precise, and persuasive, Neal's writing captured the spirit of this unique period of American history.

Notes

1 Larry Neal, "Any Day Now: Black Art and Black Liberation," *Ebony*, August 1969, p. 54. This volume, p. 113.

2 Neal, "Any Day Now," p. 55. This volume, p. 121.

3 Larry Neal, "The Black Arts Movement," *The Drama Review*, Summer 1968, p. 29. This volume, p. 87.

4 Neal, "Any Day Now," p. 57. This volume, p. 132.

5 Larry Neal, "The Social Background of the Black Arts Movement," *The Black Scholar*, January/February 1987, pp. 11–12.

6 Neal, "The Social Background of the Black Arts Movement," p. 12.

7 Larry Neal, "And Shine Swam On," in *Black Fire: An Anthology of Afro-American Writing*, ed. LeRoi Jones and Larry Neal (New York: William Morrow, 1968), p. 645.

8 Larry Neal, "A Reply to Bayard Rustin: The Internal Revolution," *Liberator*, July 1965, p. 7.

9 Larry Neal, "The Assassination of Malcolm X," in *The Sixties: The Decade Remembered Now, by the People Who Lived It Then*, ed. Lynda Rosen Obst (San Francisco: Rolling Stone Press, 1977), p. 154.

10 Neal, "And Shine Swam On," p. 645.

11 W. E. B. DuBois, "The Strivings of the Negro People," *The Atlantic Monthly*, August 1897, p. 194. Quoted in Neal, "Any Day Now," p. 54. This volume, p. 115.

12 Neal, "The Black Arts Movement," p. 29. This volume, p. 87.

13 Neal, "Any Day Now," p. 54. This volume, p. 114.

14 Amiri Baraka, "The Black Arts Movement," in *SOS—Calling All Black People: A Black Arts Movement Reader*, ed. John H. Bracey Jr., Sonia Sanchez, and James Smethurst (Amherst, MA: University of Massachusetts Press, 2014), p. 11.

15 Larry Neal, "The Black Writer's Role: Richard Wright," *Liberator*, December 1965, p. 20. This volume, p. 48.

16 Larry Neal, "The Black Writer's Role: Ralph Ellison," *Liberator*, January 1966, p. 10. This volume, p. 62.

17 Larry Neal, "Books: *Shadow and Act* by Ralph Ellison," *Liberator*, December 1964, p. 28. This volume, p. 32.

18 Larry Neal, "A Conversation with Archie Shepp," *Liberator*, November 1965, p. 25. This volume, p. 47.

19 Larry Neal quoted in "A Survey: Black Writers' Views on Literary Lions and Values," *Negro Digest*, January 1968, p. 81.

20 Larry Neal, "*New Grass* / Albert Ayler," *The Cricket: Black Music in Evolution*, Issue 4, 1969, p. 153. This volume, p. 138.

21 Neal, "The Social Background of the Black Arts Movement," p. 18.

22 Neal, "The Social Background of the Black Arts Movement," p. 12.

23 Neal, "Theatre Review: LeRoi Jones's *The Slave* and *The Toilet*," *Liber-ator*, February 1965, p. 22. This volume, p. 34.

24 Larry Neal, "New Space/The Growth of Black Consciousness in the Sixties," in *The Black Seventies*, ed. Floyd B. Barbour (Boston: Porter Sargent, 1970), p. 9.

25 Amiri Baraka, "The Wailer," in *Visions of a Liberated Future: Black Arts Movement Writings*, by Larry Neal (New York: Thunder's Mouth, 1989), p. x; Ishmael Reed, "Larry Neal: A Remembrance," *Callaloo*, Winter 1985, p. 264.

26 Stanley Crouch, "The 'Scene' of Larry Neal," *Callaloo*, Winter 1985, p. 260.

Any Day Now

Larry Neal

For Black Writers and Artists in "Exile"

How many of them
die their deaths
between the slow rhythms and the quick,
between the going and becoming.
Time does not kill, life does, in
swift moments of hate. careless steps.
sharp glances over your shoulder.

So many of them, across dark oceans,
in smelly cafes, or along foreign banks,
or in the Countess's penthouse,
or on the avenues of speechlessness
where they have been made to
prostitute their blood
to the merchants of war that manifestly loom
behind large heads and large glasses, who
explode no myths, and who are themselves
makers of myth.

How many of them die their deaths
looking for sun, finding darkness in the city of light.
motherless, whirling in world of empty words,
snatching at, and shaping the rubbish
that is our lives
until form becomes, or life dances to an incoherent finish.

Winter 1964

Review, Ralph Ellison's *Shadow and Act*
Liberator, December 1964

Who knew but that they were the saviors, the true lead-
ers, the bearers of something precious? The stewards
of something uncomfortable, burdensome, which they
hated because, living outside the realm of history, there
was no one to applaud their value and they themselves
failed to understand it. —Ralph Ellison, *Invisible Man*

There is no escaping it, Ellison is one of the best nov-
elists of our time. No writer, Black or white, seeking to
understand and comprehend the craft of fiction should
neglect reading *Invisible Man*. It is a novel which engages
both on the technical level of its style and on a whole
range of symbolic and mythic levels; it is one of Amer-
ica's most thoroughly written novels.

Ellison's latest work commands our attention not
only for what it tells us about Ellison's novel but because
of what it tells us about Ellison himself. It consists of es-
says and reviews dating from 1944 to the present, and
covering a number of topics, from twentieth-century
American fiction, the creative act in writing and mu-
sic (particularly African American music), to the race
question.

If there is any one consistent and painfully reiterated
theme, it is the necessity of the writer to confront him-
self and his history forthrightly, and to control the chaos
around him by the use of technique which lends mean-

ing to the tragic condition of man. Ellison seeks the universal and unchanging in man, and believes that myth and ritual provide the best outline for understanding the nature of the human condition.

With respect to the Black writer, Ellison believes that it is not a question of protest so much, but an affirmation of those "qualities which are of value beyond any question of segregation, economics or previous condition of servitude." And further, it is good writing which ultimately designates the meaning of a work, rather than the intensity of its outcry.

The writer must confront change and preserve those "human values which can endure...."

In terms of the positive needs of the Black writer, there is much to be gained from reading these essays, because they affirm the richness of the Afro-American tradition and give the potential writer hints as to how this tradition organically functions in a work of art.

But there is more to be understood than that which Ellison so completely expresses. Ellison is a man who has come face to face with himself and the nature of Western civilization as it relates to that self. He has shaken hands with Whitman (made a pact, so to speak), had coffee with Charlie Parker and Beethoven, and shared corn bread with Jimmy Rushing and Jascha Heifetz. He is a Black prototype of the "Renaissance" man.

But Black writers are discovering, and very quickly, that this is not always the most perfect route to take toward understanding their particular roles as creative

writers, and activists in the social affairs of man. Those of us who have the "opportunity" to obtain what this society so glibly calls "education" have found that what is being offered is useless in terms of the situation in which we find ourselves. Consequently, we refuse to produce work that sacrifices a moral commitment for something called "craft." A concept which itself presupposes something about the relationship of man to the artistic experience.

No, there is no disputing much of what Ellison has to say about these things. The real issue, as I see it, is the function of art, not in the Marxist sense which also proves to be inadequate for us, but in the sense that what is expressed is felt. And, as in jazz, there is a unity between the audience and the performer. This is the relationship that many Black writers are searching for today. Having rejected Western culture, with its stuffy artiness, they are trying to understand the values of what can be called African culture(s). These they feel are positive, and lead away from the death-centered focus of Western culture.

Many are seeking a more humanistic context in which to write, one that would eliminate the necessity of defending one's work from attacks by non-writing leftist critics who are more interested in pushing a particular political line than in the problems of artistic expression.

That one writer should reveal so much of himself and what he has come to believe testifies to an earnest attempt to understand the nature of life, and his particu-

lar stance with reference to it. It is ultimately the necessity of the writer to seek "truth" to which all viewpoints, critical and social, must eventually pay homage. These essays represent a restless search for truth in all of its elusiveness, and there is much that the reader can learn from them.

Review, LeRoi Jones's *The Slave* and *The Toilet*
Liberator, February 1965

If Bessie Smith had killed some white people she
wouldn't have needed that music. She could have
talked very straight and plain about the world. No met-
aphors. No grunts. No wiggles in the dark of her soul. Just
straight two and two are four. —LeRoi Jones, *Dutchman*

These two plays by LeRoi Jones are significant not only
for what they tell us about the nature and the possibili-
ties of the dramatic form; they are significant attempts
on the part of a Black writer to examine the particu-
lar malaise we know as "Western culture." They are at-
tempts to break down the barriers separating the artist
from the audience to whom a work must ultimately ad-
dress itself.

The very act of putting something in dramatic form
presumes that there is an audience—outside of the art-
ist's private one—to which a collective set of values must
be conveyed; and it is in the language of a play that cer-
tain pressing ideas can best be expressed. Seen in these
terms, Jones's plays are the verbal companions to the
expressions that have reached their greatest intensity
in the music of Coltrane, Ornette Coleman, and more
lately Archie Shepp.

The Slave is a play about racial conflict; about the con-
flict of ideas and words in the Western Hemisphere to-
day; about revolution, public and private; and about the

ultimate possibility of man ever making a world free of the lies and ideological flip-flopping that characterizes our existence here in America.

The play is set some time in the future. The Black people have mounted a revolution against the whites, and they are winning. Having assumed control of all of the radio stations, they are softening up the city for seizure with an all-out artillery attack. This is the setting to which Walker Vessels, Black revolutionary leader, returns. The play takes place in the home of his former wife, a white woman, who has remarried a white literature professor and former friend of the leader.

The meeting of the three people is full of all the intensity and violence that is raging in one way or another within all of us. More than once Walker is forced to brutalize the professor into recognizing that he is not "playing," that the matter confronting all three of them is a serious one, and that beneath his pretended cheerfulness there lurks a tendency to destruction. The professor comes to recognize this only after testing Walker, who disposes of the professor's notions by a violent display of temper and sardonic humor.

It is after this incident that the play moves into the essential argument underlying Walker's presence there in the first place. The argument is an extension of the conflict that is being physically waged outside; it now takes place inside, in the home, where ultimately all things begin and end.

The real conflict, as this writer sees it, lies in Walker's

battle with the intellectual forces of Western society that have failed, for all of their idealism and art, to effect any real changes in the corrupt world which intellectuals say they deplore, and which they write and argue about at great length. Walker is the Black intellectual artist, trapped by it all, fighting to destroy it, but questioning, perhaps prematurely, the nature of what will exist in its place.

Walker's desire to take his daughters from his wife and the professor is merely an attempt to retrieve something worthwhile from the rubble of a crumbling society. It is an attempt to start again with that which is viable and capable of becoming the real beginnings of a new world. If given the wrong focus, Walker might be viewed as the "villain"; but if one views Walker as the hero, the storybook variety, but intellectually more refined—who returns to Hell, or to the burning city to rescue what is pure and worth redeeming—then Walker is the hero and Grace and Bradford the "villains."

But Walker is not a storybook hero. He is a Black man torn up inside, faced with the brutal fact that he has killed to achieve something which, in its basest sense, is merely the transferal of power from white hands to Black. This is good; but what goes with it is the responsibility for setting up a new, more humanistic society.

Walker doesn't promise that a society run by Black people will be a "better" one. No one can. When Bradford asks Walker if "the have-not peoples become the haves. Even so, will that change the essential functions

of the world? Will there be more love or beauty in the world ... more knowledge ... because of it?" And Walker replies, almost like somebody you might have heard on 125th Street:

"Probably. Probably there will be more ... if more people have a chance to understand what it is. But that's not even the point. It comes down to baser human endeavor than any social-political thinking. What does it matter if there's more love or beauty? Who the fuck cares? Is that what the Western ofay thought while he was ruling ... that his rule somehow brought more love and beauty into the world? Oh, he might have thought that concomitantly, while sipping a gin rickey and scratching his ass ... but that was not ever the point. Not even on the Crusades. The point is that you had your chance, darling, now these other folks have theirs. [*Quietly*] Now they have theirs."

And Bradford replies: "God, what an ugly idea." And it is an "ugly" idea, if approached in terms of the false idealism that represents the American intellectual establishment. It is the same story: the Western liberal faced with the challenge of Black leadership in a world that demands new orientations cannot make the leap to understanding that Black people must be allowed to explore the potential locked within them without turning to violence.

Therefore Walker is correct: Bradford is just another "idea" man who, when faced with a power showdown, falls back on the empty intellectualism that bears no workable relationship with the world outside of it.

Hence, the shooting of Bradford is dramatically and ritually necessary, and for this writer was true to the dramatic outlines of the play.

The Slave is a startling play. It is profound, but understandable; its argument is one to which Black people must be exposed; and the character that Jones has drawn in Walker is a very real one; there are many beautiful moments—the combination of Walker's soul as a Black man with a certain kind of history, and his tendency toward Western intellectualism is very neatly poised one against the other. Al Freeman does a superb job in this very difficult role.

The Toilet moves at a much quicker pace than *The Slave*. The young actors, many of them from the cast of *The Cool World*, are among some of the best talents on the scene today. This play is about the search for love under conditions that militate against it ever surviving past the destructive elements that crop up to block it.

The action takes place in the lavatory of a boys' school, or some other public institution. When the play opens some of the boys are preparing to gang up on a Puerto Rican boy who has written one of the boys a letter—a love letter. The boy who received the letter is urged against his own judgment to fight the boy who, in a burst of passion and honesty, exclaims that he loved the "real" person behind the mask of toughness and violence. The others gang up on the Puerto Rican and beat him, allowing Foots, the boy, a moment of compassion only after the others have gone.

These two plays are incisive examinations of a society that is self-destructive and which, even when it falls as a collective whole, forms its sickness to obscure the possibilities that are buried within all of it. Both plays are among the most racially conscious literary works in the history of Afro-American or American drama. Both are steps toward building a body of literature to which Black people can point with pride, and can be assimilated into the life-and-death drama which is the coming Black revolution in America.

The Cultural Front

Liberator, June 1965

For those who would relegate the cultural aspects of the Afro-American's liberation struggle to a minor role, let them consider this: The political liberation of the Black Man is directly tied to his cultural liberation. Any Black organization that overlooks this point will find themselves sorely out of step with the needs of our people. What we can learn from the Muslims and later Malcolm is that one of the most direct avenues of arriving at a political understanding of the Afro-American is through his culture; specifically artistic culture. This is by no means an original statement. Garvey demonstrated its validity by using his knowledge of Afro-American culture to build the largest mass movement that has ever existed among Black people in this country; DuBois was groping toward it, but never completely examined it. Recently, Harold Cruse has been seeking to formalize his thoughts along these lines; and LeRoi Jones comes closest in *Blues People* to actually using at least one important aspect of Afro-American culture—music—to understand *who* the Afro-American *is* and who he desires *to be*.

Youth Conference on Afro-American Culture Held

The Afro-American Cultural Association (AFCA) and the Squires held a youth cultural conference at Kappa Alpha Psi fraternity house in Harlem on April 9, 10, and 11.

The theme of the conference was: The Role of the Afro-American Artist. There were a number of seminars and films which essentially related to this theme. The overall drive seemed to be to arrive at a more organic sense of the artist's role vis-à-vis his community. The discussions centered, specifically, around such questions as: Can an art that genuinely meets the needs of Black people be evolved in the community? What has prevented the Black artist from being more responsive to the needs of the community? The answers did not come easy. The Black artist is affected by the same oppressive conditions which affect his brothers and sisters; and a discussion of his role apart from the overall conditions of the society is impossible.

There were discussions in African history and culture, theater, writing, African philosophy, photography and filmmaking, nationalism, and a special discussion on the social role of the Afro-American woman.

Many persons participated in these discussions. Among which were: Dan Watts, LeRoi Jones, Charles Patterson, Harold Cruse, Nana O. Serjemen Adefunmi, Selma Sparks, Clayton Riley, C. E. Wilson, Leroy McLucas, and Audley Moore and Dr. Jochannan, whose presence gave the conference historical and scholarly weight.

Such a conference had never been held in the Harlem community before; and thus, represents a tremendous step forward in the struggle of Black people to liberate themselves.

The Black Arts Arrive

The Black Arts officially opened their school on April 30 with an explosive evening of good poetry. (See April *Liberator*.) I say explosive because the Black community has not really been exposed to the work of her sons and daughters who, for a myriad of reasons, have been busy elsewhere. The idea behind both this event and the one discussed above is to open a dialogue between the artist and his people, rather than between the artist and the dominant white society which is responsible for his alienation in the first place.

When one hears the poetry of Rolland Snellings, David Henderson, Calvin Hernton, and the other fine poets represented that night, one is certain that soon there will be no need for a dialogue, but that the artist and the community will be one voice wedded in an assault on racist America.

I believe that the highlight of the Black Arts weekend was the short parade which it held on Saturday morning in Harlem. Imagine jazz musicians, African dancing, and a group of groovy Black people swinging down Lenox Avenue; while everybody freely plays their instruments, and fine Black girls give out bright yellow circulars that say: THE BLACK ARTS IS COMING! It was Garvey all over again. It was informal and spontaneous and should illustrate something of the potential for creative encounters existing in our community.

The Black Arts had a party and a jazz concert on Sat-

urday night; and on Sunday a panel discussion on the Black Artist and Revolution. It was too bad that there were problems which prevented a healthy discussion of this topic; because it remains a pressing question, one that will have to be discussed in its own terms, and not out of our personal bags.

These two groups will be having programs in the future. Their success will depend upon two things: Whether they *really understand* what the needs of the Black community are; and meet these needs, rather than *impose* needs from the outside. And whether they are prepared to let the community participate in the process of evolving a community art.

A Conversation with Archie Shepp
Liberator, November 1965

"We must have musicians who can speak . . ."

Archie Shepp is a very capable musician, and he can speak with authority and insight on a variety of topics. He is a musician who is obviously interested in extending the meaning of his work beyond the confines of the music itself. Not only does he feel that music must play a social role in changing the society, but that he must himself actively participate in the process of transforming society. Our discussion was essentially concerned with the political and social milieu in which the Black artist is fighting to survive. Shepp is one of the better known of the musicians in the "new thing," so we asked questions that touched on the techniques now being used by contemporary Afro-American musicians.

We asked Archie if there was a conscious cultural orientation behind his music. He answered, "It is conscious and implicit in anyone's music—any *Black* person's music. It is impossible to live in America and not be aware of this." We then asked Shepp about possible influences upon his music. He replied, laughing, "Well, essentially, poverty. I think my music is derived from the culture of the poor, a common culture." This statement recalled to mind a composition on Archie's latest album, called *Hambone*. It is based on the folk rhyme that most of us recited as kids.

Archie feels that the social situation is implicit in the music of the Black musician. However, he states: "There are limitations—music has its limitations, especially in *intense* political times. Some people may call them revolutionary times. At times simply to play is not enough; but that's personal judgment. At times we must do more than play. Because, I think, whites in America have allowed themselves the luxury—we have been reluctantly forced to give that luxury—of interpreting our music any way they see fit. . . . Those people who went to the red-light district in New Orleans. What did they hear? What did they see? What did they choose to hear? . . . It is a question of what they choose, not what the artist intended." "Would you say," I asked, "that what they bring to the music are *their* hang-ups?" Archie: "Of course, and one of their hang-ups is never to put the Black musician on an equitable footing with their own. The Black man's music becomes a kind of curio, an oddity."

He felt the conditions that the musician finds himself faced with ramify the entire Negro experience. Nothing the Black man does in America is ever taken really seriously until Black people make them take them seriously.

The Black artist is faced with some serious problems vis-à-vis the Black community. Archie hits at this when he says: "I think it will be a long time before the Black artist and the Black community can really stand next to each other because so much has been done by power to separate them; and, for pure economic reasons, many have moved away from Harlem. Thus, a really vital

element of the community was taken away. Systematically, it was made possible for that element to be stolen from the Black community. And so differences have developed. I think it would be very difficult for Cecil or Ornette or myself to just go up to Harlem and expect to be accepted right away—as good as our intentions may be."

Shepp suggested that a great deal of the music being played by his contemporaries, and listened to by the public, was greatly influenced by "bourgeois techniques."

"Black musicians," Archie asserts, "must take a more rational approach to the problems of emancipation. I used the word 'rational' very advisedly because I think that the whole question of nationalism has really confused the issue." "Why is this so?" we countered. He answered: "It has added a tremendous élan to the issue. Of course, now that we are aware of negritude, being Black, all that's good. But the solution of our problems is one that requires and will require a practical, sound political strategy."

"But how can we make the art more meaningful to our people?" I asked.

"I could advocate more musicians listening to rock and roll," he said. He then expressed a preference for Ben E. King, Dionne Warwick, and the early Ray Charles. "I dig Dionne and them," he continued, "but we have to take advantage of a certain overview which we have that others don't have. Other people may have an intuitive working-class instinct, but it takes the intelligentsia to give that order and to make it meaningful. So a person

like Dionne, who we can see, who we can dig, is where that's at. We can dig what that means, but that's easily misconstrued in 1965. No, we can't settle on that. For that reason, if for no other reason then, the avant-garde musician can't save his message; he must state it. Dionne, her message is groovy; but Cecil can talk, and I can talk, and Dixon can talk. And we have to have musicians who can speak. That is important because things are too easily misconstrued. Things are too easily interpreted if left to the imagination. Art must not be left to the imagination any longer."

"What can the artist do?"

"Even if the artist has to forsake some of his most cherished things—then he must forsake them. If I have to get into rock and roll, somehow, I've got to slide into that, and refer to the people so that they'll know what I mean."

Archie's latest record, *Fire Music*, is currently on sale. One selection begins with a poem to Malcolm. Shepp's music is about the Black man's search for a social definition that affirms his manhood. The best of the New Music is a search for substance and a fundamental encounter with the social realities of America.

The Black Writer's Role: Richard Wright
Liberator, December 1965

What is the role of the Black writer in these intense political times. This question has been asked before, and it will continue being asked until the writer comes up with a satisfactory and workable answer—something he has failed to do. It is pathetic that, considering the present crisis with which Black people are faced, this question has not been settled in a manner that suits the collective needs of Black people. The writer must accept the responsibility of guiding the spiritual and cultural life of his people. He must begin to evolve his techniques and forms in light of the Black community's needs. So far, we have had only confusion. Intelligent men like Ralph Ellison, whose Invisible Man *is an important novel, have further complicated the issues by either isolating themselves from the community or advocating Western critical theories which, finally, concede to a non-functional, actionless concept of literary art. This society must be changed. The writer must be a part of that change. He must be the conscience and spirit of that change. The Black writer must understand that his destiny as an artist is ultimately bound up with, and integral to, all other aspects of the human condition.*

This article is the first of a series on the ideas, values, and problems of the Afro-American writer. We will discuss some of the ideas that Richard Wright contributed toward bringing clarity to the issues under discussion here.

Protest Literature

Richard Wright's novel, *Native Son*, is usually referred to as an example of "protest literature." I, personally, find this designation slightly inaccurate, but for the purposes of this article will not enter into a polemic that would further cloud the issue.

James Baldwin wrote an essay entitled "Everybody's Protest Novel" in which he attempted to analyze and explain the basic shallowness of the protest novel, the worst example of which is Harriet Beecher Stowe's *Uncle Tom's Cabin*. However, Baldwin made the mistake of placing or implying that *Native Son* is somewhere in the same category. In his book *Nobody Knows My Name*, Baldwin explains how this essay affected his friendship with Richard Wright:

> I had mentioned Richard's *Native Son* at the end of the essay because it was the most important and most celebrated novel of Negro life to have appeared in America. Richard thought that I had attacked it, whereas, as far as I was concerned, I had scarcely even criticized it.

Wright considered the essay not only as an attack upon him but an attack on all American Negroes because he felt the "idea of protest literature" was being attacked. It is my opinion, and I will return to this later, that Wright and Baldwin both missed the point. The

central thesis of this series is that the Black writer's problem really grows out of a confusion about function, rather than a confusion about form. Once he has understood the concrete relationship between himself and society, then the question of form can be seen differently. He will then be forced to question the validity of the forms that have been forced upon him by society, and construct new ones.

Native Son is a classic of modern American literature. Its impact on Afro-American writing is still being felt. Upon publication in 1940, it was the subject of almost violent debates; especially between Black and white members of the Communist Party to which Wright belonged. These debates and exchanges touched on every aspect of the novel from its use of violence to what some saw as a "lack of proletarian consciousness." Wright's popular novel exposed America to its malignancy; a malignancy festering beneath the blackface image of the dancing Negro smiling and making love in his *Nigger Heaven*. Its message was a harsh one. And everyone who read *Native Son* was, in some way, affected by it. Bigger Thomas—Wright's damned hero—became the most famous Negro in American fiction, except, perhaps, for Nigger Jim in *Huckleberry Finn*. However, Bigger was no clown, no loving father figure to play pranks on; but a confused and frightened product of the slums of North America. Driven and urged on to violence out of a fear stemming from the Black man's first contact with the West. Bigger is forced to commit two murders: first he murders

the liberal daughter of a white philanthropist, then his own girl whose knowledge of Bigger's crime also makes her dangerous. Who, the novel asks, is responsible for these murders. Bigger? Did he create the situation which led to the murders? Who made him and his people live like rats, and finally die like rats? *Native Son* asked these questions in an impassioned manner that could not be ignored. It opened up a strong movement among writers like Chester Himes and Willard Motley. Ellison himself refers to Wright as a "literary cousin." *Native Son* is considered throughout the world as one of America's greatest literary achievements.

Wright's Attitude about the Role of the Writer

Native Son was a great success. But what did Wright feel was the role of the Black writer? Was there a special role consigned to the Black writer? Or were his problems purely aesthetic—concerned essentially with the traditional problems of craft and literary excellence? Does politics have anything to do with the Black writer's role? What about an Afro-American culture—an Afro-American tradition; do these have any bearing on the problems confronting Black writers? Wright dealt with these questions very early in his career. We believe—that to some extent— he provided valuable answers to these questions, even if he himself was never able to put them into practice.

In 1937, *New Challenge*, a little magazine that had sprung out of the "Negro Renaissance" published an

essay by Wright entitled "Blueprint for Negro Writing."
It is one of the most important essays on the role of the
Negro writer. In it Wright clearly defines all aspects of the
Black writer's role; especially as it is related to his status
as an oppressed individual.

Wright saw the problem in this manner: The Negro
writer had taken to writing as an attempt to demonstrate
to the white world that there were some Negroes who
were "civilized." Or it (the writing) had become the voice
of the educated Negro pleading with white America for
justice. The writing "was external to the lives of educated
Negroes themselves." The best of this writing was rarely
addressed to the Negro, his needs, his sufferings, his
aspirations.

Here is the criterion on which this series is based.
It is precisely here that almost all Afro-American litera-
ture has failed. Our literature has succumbed to the role
of merely providing entertainment to white people. We
have failed to create a dynamic body of Afro-American lit-
erature, addressed, as Wright suggests, to the suffering,
needs, and aspirations of Black people. The Black writer
is, generally, caught up in the artistic standard of West-
ern capitalistic society. He is a divided person, confused
between loyalty to his own people or to the oppressing
society. His is a desire to be accepted on his own terms.
Rather than on those forced upon him by white critics
and others who are not aware of his problems. Every
Black writer is, somehow, engaged in a battle with him-
self to discover his own dynamic vis-à-vis his status as

an artist and a member of an oppressed group. Wright's essay suggests that the writer circumvent this problem by accepting his responsibility to his people.

He was insisting upon an approach to Afro-American literature which reconciled the Black man's "nationalism" and his "revolutionary aspirations." The best way for the writer to do this was to utilize his own tradition and culture. A culture which had developed out of the Negro Church, and the folklore of the Negro people. About the church, Wright explains:

> It was through the portals of the church that the American Negro first entered the shrine of Western culture. Living under slave conditions of life, bereft of his African heritage, the Negroes' struggle for religion on the plantations between 1820–1860 assumed the form of a struggle for human rights. It remained a relatively revolutionary struggle until religion began to serve as an antidote for suffering and denial.

But it was in his folklore that the Black man achieved his most "indigenous and complete expression":

> Blues, spirituals, and folktales recounted from mouth to mouth; the whispered words of a black mother to her black daughter on the ways of men, to confidential wisdom of a black father to his black son; the swapping of sex experiences on street corners from boy to boy in the deepest vernacular; work

songs sung under blazing suns—all these formed the channels through which the racial wisdom flowed.

If the writer was to address his people, it would be necessary for him to understand their culture, in order that the people would implicitly feel their place in his work, or message.

Nationalism

What about "nationalism"? Here Wright ran into some significant difficulties. The question of nationalism occurs repeatedly in the works of Richard Wright. It is clear that within Wright himself there was a great conflict being waged over the validity of nationalism. In the essay now under discussion, "Blueprint for Negro Writing," he forces the question into the open by asserting the necessity of Black people recognizing the collective nature of their struggle:

> Let those who shy at the nationalist implications of Negro life look at the body of folklore, living and powerful, which rose out of a unified sense of a common life and a common fate. Here are those vital beginnings of a recognition of a value in life as it is *lived*, a recognition that makes the emergence of a new culture in the shell of the old. And at the moment that this process starts, at the moment when a people begin to realize a *meaning* in their suffering, the civilization that engenders that suffering is doomed.

This statement is clearly in support of nationalism. But a further reading of the essay reveals that Wright really had not decided that the issue of nationalism exists paramount to other political ones. Namely, Wright's involvement in the Communist Party. The Party had a policy of discouraging nationalism. In *The God that Failed*, Wright tells how a friend of his was expelled from the Party on the grounds that he was too nationalistic:

"Dick," he said, "Ross is a nationalist." He paused to let the weight of his accusation sink in. He meant that Ross's militancy was extreme. "We Communists don't dramatize Negro nationalism," he said in a voice that laughed, accused and drawled.

Therefore, "Blueprint for Negro Writing" attempts a kind of reconciliation between nationalism and communism. In some respects Wright succeeds. For the nationalism that Wright is concerned with is a nationalism of action. American Communism, with its ideology of action, was a significant force in the development of Black writers and intellectuals. But it proved to be harmful to the long-range development of an organized and cohesive outlook among Black people. For the Party drained off the best of the Negro intelligentsia, and channeled their energies into areas that have proved particularly uncreative—uncreative in terms of unifying Black people into a force that could decide their own destiny. But Wright understands the necessities and realities of nationalism when he says:

There is, however, a culture of the Negro which is his and has been addressed to him; a culture which has, for good or ill, helped to clarify his consciousness and create emotional attitudes which are conducive to action.

This action must arise for Black people out of a common sense of destiny and purpose. The artist must utilize that culture to enable Black people to realize that destiny and purpose in a collective fashion. Richard Wright attempted to lay a theoretical foundation on which future Afro-American writing could be based. This writer feels that most of what Wright had to say about these matters is valid, but that it needs further examination. In the next part of this series we will continue our discussion of Wright and examine the questions that we have raised in light of recent developments in Afro-American writing.

The Black Writer's Role: Ralph Ellison
Liberator, January 1966

In the first article of this series, we discussed Richard Wright's contribution to the literature of Black Revolution. We attempted to explain some of the difficulties that have confronted Black writers. In that connection we briefly mentioned Wright's confrontation with Baldwin over the concept of "protest literature." We asserted that it was not a question of whether literature was *protest* or not, but in fact the *function* of literature in society. Especially in a society that, for the most part, suppresses and contains Black manhood and dignity. This article will further examine the Black writer's role. We will continue discussing Wright's problems vis-à-vis Black literature and will touch upon the ideas of Ralph Ellison.

Western intellectual elites all assume that the artistic experience is an essential one. That art is a necessary component to civilization. They assume that man needs and wants art. Also assumed is the ability of art to transcend life. Art is looked upon as a transforming force, which deepens man's spiritual and human possibilities. Now, Black writers make the same assumptions as white ones. For example, Wright never questioned the usefulness of art. The political-economic culture that we are born into already places values on certain acts. In a capitalistic society for the most part literary art is directed at the society's bourgeois needs.

Therefore, unless the Black writer was willing to evolve a dialogue between himself and the community, his work would simply be *entertainment* for literate whites. This was due to the economic condition of Black people. A condition that made them seek more immediate and traditional kinds of entertainment. There were some exceptions. For example, my father and mother, both low-paid workers, had been educated by Southern Black teachers who exposed them to the works of Hughes, Wright, and Chester Himes. Of the three Wright was the most famous. Because of the controversial nature of *Native Son*, many Black people had read it and later obtained the other works of Wright which followed. Now of course we read Baldwin's books, and I suppose that the rise in college-educated Blacks has to some extent influenced the Black writer's reading audience. However that influence is minuscule.

LeRoi Jones noted in the symposium in the *Saturday Review*, April 20, 1963, that Negroes who found themselves in a position to pursue some art, especially the art of literature, have been members of the Negro middle class, "a group that has always gone out of its way to cultivate *any* mediocrity." Further Jones points out "to be a writer was to be cultivated, in the stunted bourgeois sense of the word. It was also to be a 'quality' Black man. It has had nothing to do with the investigation of the human soul. It has been a social preoccupation, not an aesthetic one." Here we disagree with Jones. The writer's role is, finally, always social.

The Negro writer did not evolve as an expression of needs of the community, but merely to express his individual suffering and estrangement from his environment. This was not true of the folk performer, the blues singer, the storyteller, and the folk singer. They were an integral part of the community, its voice and consciousness, the bearers of myth and religion. In order for the Negro to develop his craft, it was necessary for him to adopt a Western attitude toward his role as an artist. It was necessary for him to finally seek out forms that whites would evaluate as artistic.

It was necessary to evolve a social relationship vis-à-vis white America that upheld this Western orientation, and that reinforced the aesthetic validity of the *trick* in which the writer found himself.

Wright had tried to construct a new theory of Black literature. One that would move literature out of the realm of *high art*. Black literature had to become an instrument of change instead of merely a sideshow for white readers. Therefore, what Wright was finally getting at was the function of the writer *above* and beyond his so-called creative one. Between his nationalism and Marxism, one can perceive a foreshadowing of some of the ideas being articulated by writers like Rolland Snellings and LeRoi Jones. That is, the writer's relationship to his people should be priest-like. The writer contains the soul of his people—their songs, myths, folkways, proverbs. And this unique involvement in the soul of his people should force upon him a certain responsibility

to and for their spiritual life. Wright never went this far. But he implies such a relationship when he says, speaking of nationalism: "they [Black writers] must accept the concept of nationalism because in order to transcend it, they must *possess* and *understand* it. And a nationalist spirit in Negro writing means a nationalism carrying the highest possible pitch of social consciousness. It means a nationalism that knows its origins, its limitations."

There was much about Wright which made involvement in political movements disconcerting. Wright was an outsider who tried to break down the wall between himself and others but was constantly aware of the myriad ways in which people attempt to manipulate and control others.

With respect to the ideological limitations, the Communist Party had extended its friendship and organizational power to many developing Black writers. Wright was published in the following Communist oriented magazines, *Masses and Mainstream*, *New Masses*, *International Literature*, *Anoil*, *Midland*, and *Left*. Several of the literary quarterlies managed by Black writers and critics were in fact controlled by the Party. What were the effects of the Party then on the Black writer?

First, as we have already seen with Wright, the Party did not want to encourage "Negro Nationalism." If there was any position held on nationalism at the time it was to discourage it, or to at least contain it. However the Party recognized the tremendous influence that Garvey

had had on Black people, but it felt that "nationalism was essentially bourgeois and hence had no place in an international movement."

The Party's influence, however initially helpful, proved to be deleterious. Black writers became disillusioned with the *showcase* role the Party wanted them to play. Writers like Ellison rightly felt a kind of intrusion of their integrity. The Party did not help matters much. It began losing its appeal to Black writers because of their disenchantment with it. This disenchantment was mainly due to the Soviet Union's vacillating relationship with Nazi Germany, and to the Party's deep misunderstanding of the American political situation.

Ralph Ellison – A Vague Kind of "Nationalism"

Wright broke with the Party in 1944. Himes's *Lonely Crusade* documents several kinds of Party failures in regard to Black people. Where was there to go? What center of political activity could have handled the Black writer.

Had not all organized groups proved finally harmful. Did this not mean that Black writers must exist *outside* of organized political movements, and strike out on their own? If so, wasn't there still remaining a spokesman-like role for the writer? Perhaps it was the role assumed by Baldwin in the past several years; the role of the verbally engaged writer.

Discussing Ralph Ellison is not a simple matter. One problem is that Ellison, for all of his aloofness, poses a

conflicting set of problems. Ellison is a divided man. His creative works are for the most part grounded in a kind of Afro-American folk tradition, especially in the linguistic sense. Ellison is probably a walking repository of Afro-American myth, folklore, rhymes, and blues. He must acknowledge this. On the other hand, Ellison's critical ideas are derived mostly from writers like T. S. Eliot, Kenneth Burke, Ezra Pound, and André Malraux.

There are aspects of Afro-American culture that Ellison feels must be approached from a "myth ritual" point of view. In his review of LeRoi Jones's *Blues People*, he admonishes the author for failing to use the themes of the Cambridge school and Stanley Edgar Hyman.

Ellison is not trying to escape from his Blackness per se. He is perfectly willing to utilize these elements of what he calls "the Negro experience" for his creative ends. *Invisible Man* does just that. And hence, as a novel, it is one of the great works of American fiction. He is a master of language, rhythm, irony, and humor.

It is the story of a young man who is initiated into the realities of life by undergoing several traumatic experiences. He is a success-oriented Negro who has illusions of becoming a college administrator, a professor, and finally a "Negro leader."

Through all of these stages he is transformed and comes more and more aware that people refuse to see his essential uniqueness; and for this reason, individuals or groups attempt to manipulate and control him, attempt to rob him of his identity—his face. He is treated

like a symbol instead of a flesh-and-blood individual. He is invisible.

In his ritual journey northward, he is confronted with a series of crises. In each one he plays a different role, each role plunging him further and further toward self-discovery—enlightenment. But it is an enlightenment which takes place outside of history—outside of the "ordinary" material world. There are many aspects of the novel that are surrealistic and can in no way be treated with the kind of socio-critical tools operating in this essay. In spite of this fact much of what Ellison *is* can be explained by carefully reading *Invisible Man*. However, he has been explicit in his literary criticism and his several interviews republished in his book of essays, *Shadow and Act*.

Ellison is a "cultural nationalist," and has been for some time. Just specifically what does this term mean in this context? Simply that Ellison is not attempting to escape from Afro-American culture in its various manifestations. He is interested in utilizing those elements out of Afro-American folklore in his creative work. These are invaluable situations created by the race over a period of years, and can act as the historical-mythic basis for creative fiction and art.

"It [folklore] preserves mainly those situations which have repeated themselves again and again in the history of any given group. It describes those rites, manners, customs, and so forth, which insure the good life, or destroy it; and it describes those boundaries of feeling,

thought, and action which that particular group has found to be the limitation of human condition. It projects this wisdom in symbols which express the group's will to survive; it embodies those values by which the group lives and dies. These drawings may be crude but they are nonetheless profound in that they represent the group's attempt to humanize the world. It's no accident that great literature, the products of individual artists, is erected upon this humble base."

Ellison's sources are essentially Black not white. Some of his techniques, of course, are the result of intensive reading of European writers. But that is not the issue. The issue is the function of literature and the total role of the artist vis-à-vis his community. Again it is not a question of protest per se. It is basically the unity of art and ethics, action and reaction. The writer's role is to articulate not only his perceptions, but those of his people. He functions in *any* capacity that the situation demands. His work is directed to Black people, whites are incidental to it. Ellison's work, for all of its beauty of style, and depth of perception, is read by more whites than Blacks. To what extent is the writer responsible for the situation? The artist must be a part of the condition in which he exists. If that condition is an oppressive one, he must use his work not only to transcend that condition, but to destroy it. If he is interested in his people, he will place his work where it can reach them. If not, he will continually beg the question, by resorting to nice-sounding literary chitchat. Note, for exam-

ple, these words in reply to Irving Howe's comments on Ellison which appeared in *Dissent*: "My goal was not to escape, or hold back, but to work through; to transcend, as the blues transcend the painful conditions with which they deal. The protest is there, not because I was helpless before my racial condition, but because I *put* it there. If there is anything 'miraculous' about the book it is the result of hard work undertaken in the belief that the work of art is important in itself, that it is a social action in itself." We are not siding with Howe when we say "a social action in itself" is not important. The social action must have a terminal point, a destination, and a function predetermined by the artist. We suggest that for the Black artist, the only terminal point, the only goal is the psychological liberation of his people. Ellison writes at great length about the "humanity of the Negro," and *his* desire not to question that this "humanity" ever existed. There is no "Negro humanity" as long as Black people are not free to exercise that humanity. The only way humanity can find real substance is by placing it at the center of the collective spirit of the group. The myth and folklore that you write about, Ellison, must be turned inward and explored in all of its dimensions by our own people. For you are talking to white people about a humanity, the existence of which some Negroes question themselves. Hence, your art will die, unless you can bring it to us, to our institutions, to our paltry literary adventures, to our movements and countermovements. We have not forgotten that in 1943, in the *Negro Quarterly*, you said:

"The problem is psychological; it will be solved by only a Negro leadership that is aware of the psychological attitudes and incipient forms of action which the Black masses reveal in their emotion-charged myths, symbols, and wartime folklore. Only through a skillful and wise manipulation of these centers of repressed Social energy will Negro resentment, self-pity, and indignation be channelized to cut through issues and become transformed into positive action."

It has become apparent that Ellison has no intention of helping Black leadership to understand the nature and usefulness of these symbols. And thus another vital mind has been lost in the graveyard that is America. Maybe, Ellison has already done his work; maybe we're asking too much of him, of his silent and disillusioned generation.

The Black Writer's Role: James Baldwin
Liberator, April 1966

This is the third article in a series on the role of the Black writer. We have previously discussed Richard Wright and Ralph Ellison in terms of particular historical and social problems confronting Afro-American writers. What we have been trying to arrive at is some kind of synthesis of the writer's function as an oppressed individual and a creative artist.

It was Baldwin who attempted a reevaluation of the status of the American "protest novel." The attempt has opened him to much criticism. Most of it stemming from Baldwin's failure to arrive at a more deeply considered idea of the American novel; and further, his failure to utilize the "Negro tradition" to its fullest extent. Sylvester Leaks accuses him of having "studied too much English and not enough people—especially Black people."

In *Anger, and Beyond*, a collection of essays and interviews on the Black writer, Albert Murray states that Baldwin's work is now characterized by the same sense of protest that Baldwin accused Wright of in the essay entitled "Everybody's Protest Novel."

There is a certain amount of truth in both of these charges. I personally find it difficult to ascribe any particular set of artistic values to Baldwin. Simply, because he is a very complex person. His work and his friends testify to the truth of this statement. Looking over Baldwin's life since about 1948, one is confronted with a personality

who is constantly grappling with problems; constantly tearing *himself* and the world apart in order to discover some essential truth. The most striking thing about this search is its public character. It is as if the public is witnessing something on the order of a confession; and the only thing that finally saves it from being something so mundane is the excellence of the writing. His work is suffused with an incisive sense of self-pity. But it never remains simply that. It never fails to engage our attention, even when it is unsuccessful; the way *Another Country* is unsuccessful. One always senses behind the words a personality that is grappling with a large dirty world that it does not understand. A world best described by the word "conundrum"; a word which pops up often in his essays.

He knows that the white world offers no simple solutions to these conundrums, these riddles; but he hacks away at them like a Black *Job* grappling with a mystery that is ultimately larger than in any one man's life. And because he has been greatly concerned with identity, much of Baldwin's analysis of the world involves, in essence, an analysis of himself.

Baldwin, more so than Wright or Ellison, has been extremely preoccupied with identity—his identity as a Black man and as an *American* writer. I stress *American* because along with his "negroness" it is his sense of being an American that finally emerges as a central aspect of Baldwin's vision of himself:

In my necessity to find the terms on which my experience could be related to that of others, Negroes and whites, writers and non-writers, I proved, to my astonishment, to be as American as any Texas G.I. And I found my experience was shared by every American writer I knew in Paris. Like me, they had been divorced from their origins, and it turned out to make little difference that the origins of white Americans were European and mine were African—they were no more at home in Europe than I was.

And by extension of that identity, the negro is viewed as an American phenomenon:

"The story of the Negro in America is the story of America—or, more precisely, it is the story of Americans.... The Negro in America, gloomily referred to as that shadow which lies athwart our national life...."

In elaborating upon these points, Baldwin illustrates that the price which America must pay for the dehumanization of the Black man is her own dehumanization; and further the destruction of the Black man's identity is the destruction of the identity of America. Mixed up in all of this is what he calls a "fruitless tension between the traditional master and slave." Baldwin believes that this tension has nothing to do with reality.

I believe that it has everything to do with reality, however bizarre that reality may seem. Baldwin has a penchant for allowing himself to fall into a few vague idealistic traps. Mostly, it is because he is sensitive enough

to see through to the *horror*; but is unable to confront it. At least real confrontation with what must be, in his eyes, an existential oppression is constantly being sidestepped.

Baldwin usually ends up begging out by, or by falling on, a kind of super-normal kind of "love." This happens in *The Fire Next Time* where he warns America of her impending doom for her sins against Black people. In his novel *Another Country*, the characters seem to exist outside of a social context; and the choices that they make are essentially unimportant. His play *Blues for Mister Charlie* ends with a preacher taking up the Bible *and* the gun. It is as if the author cannot decide what exactly he wants his characters to do or to be. And it is this duality that is finally the most disconcerting thing about much of Baldwin's work, even the best of it.

Much of what he had to say about America, and the Black man's relation to her, was extremely timely. And, I suppose, that much of it had to be said *the way* Baldwin said it. That is, it had to offer alternatives which white America, if it were humane, could accept. Once having had a writer like Baldwin lay bare the corrupt morality of America, and in so complete and thorough a manner, a way was paved for another dynamic—a new force was unleashed among younger Black writers which had as its purpose an internal dialogue among Black people. Baldwin's impassioned essays and shrill outcries were directed primarily at white America. Hence, he joined the tradition of pleading with white America for the hu-

manity of the Negro; instead of addressing himself to Black people and their problems.

Baldwin's popularity coincided with the "civil rights revolution." And in terms of the character of the civil rights movement; his work represents both the *moral* substance of the movement, and its ultimate sterility. Baldwin's love-centeredness springs from the same sources fundamentally as Rev. King's who, by the way, is greatly admired by Baldwin. The civil rights movement made the public more aware of James Baldwin the personality; the voice crying in the white wilderness, attempting to save America.

In terms of this kind of commitment to social causes, Baldwin outdid Wright and any other writer before him. Now the awful thing about all of this activity is that it still leaves unanswered the question: *Just what is the Black writer's role?* Is it supposed to be that of spokesman? Or, again should he *just write*, as some people say? Baldwin inadvertently supplied an answer; or at least one worth examining.

Remember that it was Baldwin who criticized Wright's *Native Son* for engaging in an artless kind of protest. But Baldwin, out of desperation and a sense of conscience, proceeds to construct his literary career along lines which Wright would probably have approved.

However, it is a rather haphazard construction. It is mostly motivated by the exigencies of the social situation—this is good but Baldwin hasn't taken time, like Ellison for example, to decide on his relation to it.

Hence, it all occurs as if a man suddenly woke up in the middle of the night and found his bedroom full of people weeping and crying for some kind of assistance. So he acts, seizing upon what first comes to mind. In this action, however, lies the germ of an idea. The writer is forced to understand his relationship to certain social forces. He is forced to understand that he must take a position vis-à-vis those forces. Baldwin did just that. And in doing so, confused and enlightened many Black writers at the same time.

Confusion, because he, or few other writers, have asked themselves: What is supposed to be the function of literature in this society in the first place? Baldwin has asserted that the writer is supposed to be committed to "truth." Whose truth—the oppressed's or the oppressor's—he does not say. What we are left with is a body of literature which has no focus. Also, there is no attempt at a synthesis which supports the writer's aesthetic and political impulses. Using Baldwin as a working example, it is clear that there is a certain amount of tension underlying these problems.

But, Baldwin acting as the *conscience* of the civil rights movement comes closer than any writer before him to an essential aspect of the problem. And that is commitment to some kind of social dynamic. Here is where Ellison's priest-ritual role takes on, what I believe to be, a more significant meaning. The writer must somehow place himself at the center of the community's cultural and political activity; and perform the role as an inter-

preter of the mysteries of life. He must resist and submit, at once, to the day-to-day demands of the community.

Out of this creative tension between the individual and the collective will emerge a synthesis appropriate to the revolutionary demands of the situation. For most Black writers to engage in this kind of confrontation with themselves and their people, they must rid themselves of certain middle-class hang-ups about the value of their art to the larger society, that is, white America; and pledge themselves to the psychological liberation of Black people. All of this must be done while pursuing whatever petty offers the creative establishment makes to aspiring writers.

Baldwin's problem was that he was the conscience of a movement (civil rights) which has as its goal integration into a dying system; instead of the destruction of the *white* idea of the world. In *The Fire Next Time*, he begins to understand certain very basic things about Black people in this society; and the most important of which is that the only thing whites have that Black people should want is *power*. Further, Black people, because of the manner in which they are situated within this society, have the means of destroying the American dream. However, these are still the observations of a man who fundamentally wants to "save" America.

James Baldwin is the articulate spokesman of that wing of the Negro establishment which sees America's race problem as simply a moral question. I suggest that Baldwin performed an important service to Black

America by exposing white America's total lack of conscience. If she could ignore as impassionate a cry as Baldwin's then she was beyond saving.

As a "spokesman" for an oppressed people, Baldwin met with mixed success. As a writer for these same people, Baldwin has missed the point by a wide margin. His uncertainty over identity and his failure to utilize, to its fullest extent, traditional aspects of Afro-American culture, has tended to dull the intensity of his work. Therefore, we are still awaiting a writer totally committed to the destiny of Black people; a writer who has decided to explore in the most creative fashion possible *all* aspects of the Afro-American presence in the United States.

The Black Writer's Role

Liberator, June 1966

The trouble with most writers is that they simply want to paint pretty pictures, instead of committing themselves to something and giving direction. —William Davis

Several months ago, I went to a talk at AMSAC (American Society for the Study of African Culture). The speaker was George Lamming, the brilliant West Indian novelist. He attempted to isolate some of the most significant themes in the works of writers of African descent. He discussed passages from Senghor, Diop, Césaire, and several other West Indian writers. He read several interesting selections from his novel, *In the Castle of My Skin*; and then attempted to explain the peculiar estrangement of a Black writer working and living in the West. Much of what Lamming had to say amounted to the kind of literary disembodiment that one encounters in graduate seminars on literature. Then the question and answer period—most of the questions were knotty and confused; reflections, no doubt, of Lamming's lecture. Finally, someone asked Lamming if the people of the West Indies were getting an opportunity to read his works which are filled with the color and rhythms of the Islands. Lamming said no, looked at his staid bourgeois audience, flustered, and deplored the "horrible system of neocolonialism" which allowed such a condition to exist.

Yes, I thought, that is the issue after all. Who is the

Black writer's audience? Who are we writing for—our "neocolonialist masters" or our *own* people? Finally, this question transcends that of craft and form. Specifically, although it may seem obvious, all creative artists obtain their idea of excellence from some standard—some isolatable set of values and judgments. Lamming had spent two hours discussing Black literature with no discernible audience in mind. But his answer to the question, "Are the people of the West Indies reading your work?" indicates that Lamming is not unaware that he finds himself in a rather complicated trick.

These remarks are not to be taken as an attack upon Lamming. Most of us are in the same situation, but have refused to be as honest as Lamming. Few of us have accepted the responsibilities of directing our work to the needs of *our* people. Most of us simply seek entrance into the establishment; thereby, never completely developing a literature that mirrors the manifold realities of Black America. Essentially, we are a glorified proletariat accepting an occasional crumb from the tables of the establishment—an establishment which has yet to concede that our work has anything but *exotic* value. Under such conditions, the Black writer is just another variation of the court jester—a literary Stepin Fechit performing for an audience of white onlookers.

The recent Negro Arts Festival in Dakar immediately comes to mind. There, hundreds of artists of African descent came to what could have been a most significant event. Only, they found that it was constructed to

attract everyone but Black people. The performances were attended by ninety percent European and American whites; while the bulk of the Senegalese people either could not afford the festival, or were somehow discouraged from going. And Senghor can glibly write about *negritude* and African Socialism.

The so-called Harlem Renaissance of the twenties, although it produced a few excellent writers, is an example of a similar phenomenon, maybe its archetype. This *Renaissance* occurred at a time when white America, in a wild search for the unusual and exotic, came up to Harlem to watch extravagant productions at places like the Cotton Club, where Black people were not allowed. Many writers—Black and white—capitalized on this sudden interest in Afro-American culture by producing a literature which simply titillated the suppressed sexual urges of white America.

Meanwhile, significant Black talent like Jean Toomer, Zora Neale Hurston, and Claude McKay were never fully allowed to develop a deeply rooted Afro-American literature. Very few of our children grow up embracing the poems of Langston Hughes, or the folk-oriented stories of Zora Neale Hurston. Hence, there is a concrete relationship between the overt socio-economic oppression of the Black masses, and the suppression of their legitimate culture.

The Black creative artist is ensnared in a constricting web of contradictions and assertions which, if not resolved, will leave the artist far behind the socio-political

thrust of his people. If the Black artist truly desires to be an artist of his people, his work must have an affinity with whatever political and social forces are working toward Black liberation. These artists, particularly writers and musicians, must probe the soul of Black America. What I am speaking about is not necessarily a literature of "protest." This literature should speak for and to Black people. It should not attempt to assail the conscience of white America; its primary focus must be the developing consciousness of Black America. It should be a literature rooted in the sum total of Afro-America's experience—from our African past to our presence in the modern Western world. It will not be a lovely thing, this literature, this art; for it will have to tell the truth about ourselves, about our hang-ups, our contradictions. But in seeing ourselves with our own eyes, we will understand more deeply the nature of our existence—its beauty and profound spirituality. And we will grow strong in this knowledge.

The writer must grapple with the question of control and dissemination of his work. Black writers and artists who have achieved a significant degree of financial success must begin to develop community theaters, publishing houses, magazines, film companies, etc. We must support existing firms like Johnson publications, force them to publish meaningful work by deluging them with the best that we have.

There is a new Afro-American literature in the process of developing. It has its antecedents in Afro-American

folk culture, the folktales, blues, spirituals, and the unrecorded and recorded oral history of the people. Langston Hughes, Zora Neale Hurston, and Ralph Ellison, to name a few, have attempted to explore this culture for all of its possibilities and ramifications. There is, however, a wider area of possibilities; and the more one proceeds toward them, the more profound is the contact with the essential reality of the Black man in the West. It is this kind of contact with fundamentals that makes Ellison's *Invisible Man* one of the most significant novels of the twentieth century.

It should be clear that I am not advocating a "folk literature" per se. Rather, I am asserting the existence of a valid folk culture. That is, a primary culture which underlies the so-called higher levels of culture.

Take Killens, for example. His novels, *Youngblood*, *And Then We Heard the Thunder*, both attempt an extended examination of Black manhood and the necessity of commitment. Both of these novels—aside from Killens's liberal hang-ups—indicate that the author is in tune with certain psychological configurations in the history of Black America. In *Youngblood*, Killens creates a folk hero who is very complex, very lifelike, whose encounter with white Southern society and himself leads the reader to understand some basic truths, not only about the general human condition, but the entire social history of America, North and South.

Ellison had previously observed, the same as Killens, aspects of Southern life that can best be described as

"ritualistic." Both have a grasp of ritual transformations that deepen the wonder of human existence. But for our purposes, however, there is a certain degree of incompleteness in the works of both of these writers. Killens, operating out of a Marxist orientation, tends to force some of his white characters to unnecessary levels of commitment. Ellison, on the other hand, has had his share of "white" commitment, and is bitter about it. He ultimately suffers from a certain amount of paralysis.

But the novel is a passive form. Specifically, it is not conducive to the kind of social engagement that Black America requires at this time. Writing in the Winter 1966 issue of *The Massachusetts Review*, Sterling Brown states the following: "Times of gestation, conception, birth and early nurturing of a revolution are not necessarily times that produce creative literature." My feelings are precisely the opposite. It is at such times that a truly creative literature is more likely to flower.

Consequently, the real revolution in Black literature is occurring among the poets and dramatists. In drama, there are people like Doug Turner, LeRoi Jones, and Ed Bullins. And in poetry, we have David Henderson, Rolland Snellings, Ishmael Reed, Marvin Jackman, Ernie Allen, Calvin Hernton, Carol Freeman, Ronald Stone, LeRoi Bibbs, Welton Smith, and quite a few more.

The best work of these writers grows out of the spirit of *the* race and is rooted in the manifold experiences of an oppressed people. For example: David Henderson's "Keep on Pushing" which synthesizes the despair and

the aspiration of a new generation of Black youth. David, like Langston Hughes, has listened to the speech of his people, and has a fine understanding of how to make it work in a poem. Another poet, Ronald Stone patterns his readings, very consciously, after the music of Charlie Parker and other jazz musicians. He is all movement. He makes his body dance with the poem. He really *feels* what he is doing. Hernton is explosive, sensual, constantly tearing apart his psyche and the collective one in order to arrive at a more profound feeling of what the world is.

Black Mass, by LeRoi Jones, gives the Muslim myth of Yacub substance and artistic significance; and in a short play is able to consider philosophical questions which have confronted the West since the nineteenth century. That is, the Western tendency to create Frankenstein monsters for the so-called good of humanity.

At this writing, the majority of these writers have not been published to any significant degree. This writer has been fortunate enough to have participated in readings with these poets. Many of these writers must understand that there is little likelihood that their work will receive the kind of formal recognition from *white* America that it deserves. At present, because of the content of the material, there are few outlets for this work. However, even for those Black writers who get their works published in the larger society, their only salvation lies in turning inward on themselves and their people. They must continue to establish political-literary quarterlies like *Soulbook*, *Umbra*, and *Black Dialogue*.

The work must be taken to the people in the Black community in the most exciting fashion possible. That means we must develop visual and audio techniques to assist verbal projection. This means that anything goes: independent theaters, outdoor street readings, church readings, school auditoriums, colleges in the South, and a poets' press run by Black writers and professionals. The writer must exist to do his work as an artist. But he must recognize no essential dichotomy between himself and the political oppression of his people. He must attempt—like a priest—to operate at the core of their spiritual lives. He must understand something about the sacredness of his role—its essential spirituality and the responsibility that it entails.

The Western tendency to force the artist into a state of isolation and alienation must be resisted. It is unhealthy, and finally leads to decadence—a sickness of the soul that paralyzes and prevents the artist from perceiving the essential humanity of his people. The Black writer must not get hung up in cracker dialogues about individuality. It has no social meaning to Black people who, while upholding collective values, have never been oppressive toward creative individuality. Note, for example, the variety of forms and styles existing in Afro-American music and life.

Black writers must listen to the world with their whole selves—their entire bodies. Must make literature *move* people. Must want to make our people *feel*, the way our music makes them feel. Feel the roots of their suffer-

ing and pain and come to understand *all* of the things that they must *do* about it. The white man's idea of the world is crumbling. The most fundamental question confronting the Black artist is: whether he wishes his work to simply exist in agreement with Western decay, or can his work be a part of the ongoing substance within man that cries out for definition and self-fulfillment? The Afro-American is that part of the Third World situated in the belly of the beast. The key to its destruction. The world, so carefully described by Fanon, is waiting to see just how the deal will go down. Finally, let's end with this story: I was talking all of this over with another writer; and he said: I know things are rough, but what can I do about it, I'm only an artist? I said, Yeah, you're also a *man*—but are you? Are you?

Editorial
The Cricket: Black Music in Evolution, no. 1, 1968

The true voices of Black Liberation have been the Black musicians. They were the first to free themselves from the concepts and sensibilities of the oppressor. The history of Black Music is a history of a people's attempt to define the world in their own terms. Essentially, the Black Musicians have postulated a deeply spiritual view of the world. They have been the priests of pure wisdom, in essence the voice of a People. They have paid severely for taking the role assigned to them by the demands of the Spirit. They have been fucked over by forces representing an alien sensibility, that is, the sensibility of the Euro-American. All segments of the white power group have benefited from the gifts of Black Music. Ofay white critics have written the histories and the criticisms of our music. Slick club owners have attempted to twist the music, to make it some other thing. Recording companies have stolen the music, forcing some of our brother musicians into strange trick bags. And through all of this shit, the music has survived and propelled itself forward into more profound areas of human experience. In sum, the Black Man's most important address to his brothers and the world has been controlled by white America.

Therefore, we propose a cultural revolution. This revolution must take place first among Black Artists. We must bring all Black Art back into the community, putting it at the core of the developing Black consciousness.

The Cricket represents an attempt to provide Black Music with a powerful historical and critical tool. In assuming this responsibility, we are saying to the world that no longer will we as Black Men allow the white sensibility to dominate our lives. It is the responsibility of Black musicians and writers to finally make a way for themselves. We know that there are those among us who do not understand the importance of the cultural revolution. These very same persons must be accused of abdicating their responsibility of Afro-American culture. They have failed to write the books and histories of African American music and culture. They have been the victims of a deep-seated self-hate, a hate which made them deny our children the knowledge of Black Culture. Where are the histories and biographies of men like Charlie Parker, Sam Cooke, Lester Young, John Coltrane, Sun Ra, Otis Redding, Duke Ellington ... They are either unwritten; or when written, they are by slick would-be hip ofays who have appointed themselves guardians of Black culture. Some of the Negros who pride themselves in knowing everything Euro-American have never heard of James Brown or John Coltrane, or Cecil Taylor. They hate them Black selves, sitting in the White House listening to Bernstein, never having heard Bud Powell or Herbie Nichols. *The Cricket* advocates that the Black Artists begin to move; that we use the force of the music and the Black poem (rhythm and blues) to blow them away, to blow the white thing out of them, and take control of our own thing. We must move this way. There is no culture

otherwise. Only a stale hipness that will turn itself into an inching cancer.

We call this monthly *The Cricket* because Buddy Bolden, who is one of the fathers of Black Music, had a sheet in New Orleans by that name. Bolden's *Cricket* has been called a "gossip" sheet by the hip white boys who wrote the histories. We'll have some "gossip" for the reader and a whole lot of other shit too.

The Black Arts Movement
The Drama Review, Summer 1968

I

The Black Arts Movement is radically opposed to any concept of the artist that alienates him from his community. Black Art is the aesthetic and spiritual sister of the Black Power concept. As such, it envisions an art that speaks directly to the needs and aspirations of Black America. In order to perform this task, the Black Arts Movement proposes a radical reordering of the Western cultural aesthetic. It proposes a separate symbolism, mythology, critique, and iconology. The Black Arts and the Black Power concept both relate broadly to the Afro-American's desire for self-determination and nationhood. Both concepts are nationalistic. One is concerned with the relationship between art and politics; the other with the art of politics.

Recently, these two movements have begun to merge: the political values inherent in the Black Power concept are now finding concrete expression in the aesthetics of Afro-American dramatists, poets, choreographers, musicians, and novelists. A main tenet of Black Power is the necessity for Black people to define the world in their own terms. The Black artist has made the same point in the context of aesthetics. The two movements postulate that there are in fact and in spirit two Americas—one Black, one white. The Black artist takes this to mean

that his primary duty is to speak to the spiritual and cultural needs of Black people. Therefore, the main thrust of this new breed of contemporary writers is to confront the contradictions arising out of the Black man's experience in the racist West. Currently, these writers are re-evaluating Western aesthetics, the traditional role of the writer, and the social function of art. Implicit in this re-evaluation is the need to develop a "Black aesthetic." It is the opinion of many Black writers, I among them, that the Western aesthetic has run its course: it is impossible to construct anything meaningful within its decaying structure. We advocate a cultural revolution in art and ideas. The cultural values inherent in Western history must either be radicalized or destroyed, and we will probably find that even radicalization is impossible. In fact, what is needed is a whole new system of ideas. Poet Don L. Lee expresses it:

> We must destroy Faulkner, dick, jane, and other perpetuators of evil. It's time for DuBois, Nat Turner, and Kwame Nkrumah. As Frantz Fanon points out: destroy the culture and you destroy the people. This must not happen. Black artists are culture stabilizers; bringing back old values, and introducing new ones. Black Art will talk to the people and with the will of the people stop the impending "protective custody."

The Black Arts Movement eschews "protest literature." It speaks directly to Black people. Implicit in the

concept of "protest literature," as Brother Knight has made clear, is an appeal to white morality:

> Now any Black man who masters the technique of his particular art form, who adheres to the white aesthetic, and who directs his work toward a white audience is, in one sense, protesting. And implicit in the act of protest is the belief that a change will be forthcoming once the masters are aware of the protestor's "grievance" (the very word connotes begging, supplications to the gods). Only when that belief has faded and protestings end, will Black art begin.

Brother Knight also has some interesting statements about the development of a "Black aesthetic":

> Unless the Black artist establishes a "Black aesthetic" he will have no future at all. To accept the white aesthetic is to accept and validate a society that will not allow him to live. The Black artist must create new forms and new values, sing new songs (or purify old ones); and along with other Black authorities, he must create a new history, new symbols, myths and legends (and purify old ones by fire). And the Black artist, in creating his own aesthetic, must be accountable for it only to the Black people. Further, he must hasten his own dissolution as an individual (in the Western sense)—painful though the process may be, having been breast-fed the poison of "individual experience."

When we speak of a "Black aesthetic" several things are meant. First, we assume that there is already in existence the basis for such an aesthetic. Essentially, it consists of an African American cultural tradition. But this aesthetic is finally, by implication, broader than that tradition. It encompasses most of the usable elements of Third World culture. The motive behind the Black aesthetic is the destruction of the white thing, the destruction of white ideas, and white ways of looking at the world. The new aesthetic is mostly predicated on an ethics which asks the question: Whose vision of the world is finally more meaningful, ours or the white oppressors'? What is truth? Or more precisely, whose truth shall we express, that of the oppressed or of the oppressors? These are basic questions. Black intellectuals of previous decades failed to ask them. Further, national and international affairs demand that we appraise the world in terms of our own interests. It is clear that the question of human survival is at the core of contemporary experience. The Black artist must address himself to this reality in the strongest terms possible. In a context of world upheaval, ethics and aesthetics must interact positively and be consistent with the demands for a more spiritual world. Consequently, the Black Arts Movement is an ethical movement. Ethical, that is, from the viewpoint of the oppressed. And much of the oppression confronting the Third World and Black America is directly traceable to the Euro-American cultural sensibility. This sensibility, anti-human in nature, has, until

recently, dominated the psyches of most Black artists and intellectuals; it must be destroyed before the Black creative artist can have a meaningful role in the transformation of society.

It is this natural reaction to an alien sensibility that informs the cultural attitudes of the Black Arts and the Black Power movement. It is a profound ethical sense that makes a Black artist question a society in which art is one thing and the actions of men another. The Black Arts Movement believes that your ethics and your aesthetics are one. That the contradictions between ethics and aesthetics in Western society is symptomatic of a dying culture.

The term "Black Arts" is of ancient origin, but it was first used in a positive sense by LeRoi Jones:

> We are unfair
> And unfair
> We are black magicians
> Black arts we make
> in black labs of the heart
>
> The fair are fair
> and deathly white
>
> The day will not save them
> And we own the night

There is also a section of the poem "Black Dada Nihilismus" that carries the same motif. But a fuller amplification of the nature of the new aesthetics appears in the poem "Black Art":

Poems are bullshit unless they are
teeth or trees or lemons piled
on a step. Or black ladies dying
of men leaving nickel hearts
beating them down. Fuck poems
and they are useful, they shoot
come at you, love what you are,
breathe like wrestlers, or shudder
strangely after pissing. We want live
words of the hip world, live flesh &
coursing blood. Hearts Brains
Souls splintering fire. We want poems
like fists beating niggers out of Jocks
or dagger poems in the slimy bellies
of the owner-jews....

Poetry is a concrete function, an action. No more abstractions. Poems are physical entities: fists, daggers, airplane poems, and poems that shoot guns. Poems are transformed from physical objects into personal forces:

Put it on him poem. Strip him naked
to the world! Another bad poem cracking
steel knuckles in a jewlady's mouth

Poem scream poison gas on beasts in green berets ...

Then the poem affirms the integral relationship be-
tween Black Art and Black people:

Let Black people understand
that they are the lovers and the sons
of lovers and warriors and sons
of warriors Are poems & poets &
all the loveliness here in the world ...

It ends with the following lines, a central assertion
in both the Black Arts Movement and the philosophy of
Black Power:

We want a black poem. And a
Black World.
Let the world be a Black Poem
And Let All Black People Speak This Poem
Silently

Or LOUD

The poem comes to stand for the collective conscious
and unconscious of Black America—the real impulse
in back of the Black Power movement, which is the will
toward self-determination and nationhood, a radical
reordering of the nature and function of both art and
the artist.

In the spring of 1964, LeRoi Jones, Charles Patterson, William Patterson, Clarence Reed, Johnny Moore, and a number of other Black artists opened the Black Arts Repertory Theatre School. They produced a number of plays including Jones's *Experimental Death Unit # One*, *Black Mass*, *Jello*, and *Dutchman.* They also initiated a series of poetry readings and concerts. These activities represented the most advanced tendencies in the movement and were of excellent artistic quality. The Black Arts School came under immediate attack by the New York power structure. The Establishment, fearing Black creativity, did exactly what it was expected to do—it attacked the theater and all of its values. In the meantime, the school was granted funds by OEO through HARYOU-ACT. Lacking a cultural program itself, HARYOU turned to the only organization which addressed itself to the needs of the community. In keeping with its "revolutionary" cultural ideas, the Black Arts Theatre took its programs into the streets of Harlem. For three months, the theater presented plays, concerts, and poetry readings to the people of the community. Plays that shattered the illusions of the American body politic, and awakened Black people to the meaning of their lives.

Then the hawks from the OEO moved in and chopped off the funds. Again, this should have been expected. The Black Arts Theatre stood in radical opposition to the feeble attitudes about culture of the "War on Poverty" bu-

reaucrats. And later, because of internal problems, the theater was forced to close. But the Black Arts group proved that the community could be served by a valid and dynamic art. It also proved that there was a definite need for a cultural revolution in the Black community.

With the closing of the Black Arts Theatre, the implications of what Brother Jones and his colleagues were trying to do took on even more significance. Black Art groups sprang up on the West Coast and the idea spread to Detroit, Philadelphia, Jersey City, New Orleans, and Washington, DC. Black Arts movements began on the campuses of San Francisco State College, Fisk University, Lincoln University, Hunter College in the Bronx, Columbia University, and Oberlin College. In Watts, after the rebellion, Maulana Karenga welded the Black Arts Movement into a cohesive cultural ideology which owed much to the work of LeRoi Jones. Karenga sees culture as the most important element in the struggle for self-determination:

Culture is the basis of all ideas, images and actions. To move is to move culturally, i.e. by a set of values given to you by your culture.

Without a culture Negroes are only a set of reactions to white people.

The seven criteria for culture are:

1. Mythology
2. History
3. Social Organization
4. Political Organization
5. Economic Organization
6. Creative Motif
7. Ethos

In drama, LeRoi Jones represents the most advanced aspects of the movement. He is its prime mover and chief designer. In a poetic essay entitled "The Revolutionary Theatre," he outlines the iconology of the movement:

> The Revolutionary Theatre should force change: it should be change. (All their faces turned into the lights and you work on them black nigger magic, and cleanse them at having seen the ugliness. And if the beautiful see themselves, they will love themselves.) We are preaching virtue again, but by that to mean NOW, toward what seems the most constructive use of the word.

The theater that Jones proposes is inextricably linked to the Afro-American political dynamic. And such a link is perfectly consistent with Black America's contemporary demands. For theater is potentially the most social of all of the arts. It is an integral part of the socializing process. It exists in direct relationship to the audience it claims to serve. The decadence and inanity of the con-

temporary American theater is an accurate reflection of the state of American society. Albee's *Who's Afraid of Virginia Woolf?* is very American: sick white lives in a homosexual hellhole. The theater of white America is escapist, refusing to confront concrete reality. Into this cultural emptiness come the musicals, an up-tempo version of the same stale lives. And the use of Negroes in such plays as *Hello, Dolly!* and *Hallelujah, Baby!* does not alter their nature; it compounds the problem. These plays are simply hipper versions of the minstrel show. They present Negroes acting out the hang-ups of middle-class white America. Consequently, the American theater is a palliative prescribed to bourgeois patients who refuse to see the world as it is. Or, more crucially, as the world sees them. It is no accident, therefore, that the most "important" plays come from Europe—Brecht, Weiss, and Ghelderode. And even these have begun to run dry.

The Black Arts theater, the theater of LeRoi Jones, is a radical alternative to the sterility of the American theater. It is primarily a theater of the Spirit, confronting the Black man in his interaction with his brothers and with the white thing.

Our theatre will show victims so that their brothers in the audience will be better able to understand that they are the brothers of victims, and that they themselves are blood brothers. And what we show must cause the blood to rush, so that prerevolutionary temperaments will be bathed in this blood, and it will

cause their deepest souls to move, and they will find themselves tensed and clenched, even ready to die, at what the soul has been taught. We will scream and cry, murder, run through the streets in agony, if it means some soul will be moved, moved to actual life understanding of what the world is, and what it ought to be. We are preaching virtue and feeling, and a natural sense of the self in the world. All men live in the world, and the world ought to be a place for them to live.

The victims in the world of Jones's early plays are Clay, murdered by the white bitch-goddess in *Dutchman*, and Walker Vessels, the revolutionary in *The Slave*. Both of these plays present Black men in transition. Clay, the middle-class Negro trying to get himself a little action from Lula, digs himself and his own truth only to get murdered after telling her like it really is:

Just let me bleed you, you loud whore, and one poem vanished. A whole people of neurotics, struggling to keep from being sane. And the only thing that would cure the neurosis would be your murder. Simple as that. I mean if I murdered you, then other white people would begin to understand me. You understand? No. I guess not. If Bessie Smith had killed some white people she wouldn't have needed that music. She could have talked very straight and plain about the world.... Just straight two and two are four. Money. Power. Luxury. Like that. All of them. Crazy niggers turning their

backs on sanity. When all it needs is that simple act. Murder. Just murder! Would make us all sane.

But Lula understands, and she kills Clay first. In a perverse way it is Clay's nascent knowledge of himself that threatens the existence of Lula's idea of the world. Symbolically, and in fact, the relationship between Clay (Black America) and Lula (white America) is rooted in the historical castration of Black manhood. And in the twisted psyche of white America, the Black man is both an object of love and hate. Analogous attitudes exist in most Black Americans, but for decidedly different reasons. Clay is doomed when he allows himself to participate in Lula's "fantasy" in the first place. It is the fantasy to which Frantz Fanon alludes in *The Wretched of The Earth* and *Black Skins, White Mask*: the native's belief that he can acquire the oppressor's power by acquiring his symbols, one of which is the white woman. When Clay finally digs himself it is too late.

Walker Vessels, in *The Slave*, is Clay reincarnated as the revolutionary confronting problems inherited from his contact with white culture. He returns to the home of his ex-wife, a white woman, and her husband, a literary critic. The play is essentially about Walker's attempt to destroy his white past. For it is the past, with all of its painful memories, that is really the enemy of the revolutionary. It is impossible to move until history is either re-created or comprehended. Unlike Todd, in Ralph Ellison's *Invisible Man*, Walker cannot fall outside history.

Instead, Walker demands a confrontation with history, a final shattering of bullshit illusions. His only salvation lies in confronting the physical and psychological forces that have made him and his people powerless. Therefore, he comes to understand that the world must be restructured along spiritual imperatives. But in the interim it is basically a question of *who* has power:

EASLEY. You're so wrong about everything. So terribly, sickeningly wrong. What can you change? What do you hope to change? Do you think Negroes are better people than whites ... that they can govern a society *better* than whites? That they'll be more judicious or more tolerant? Do you think they'll make fewer mistakes? I mean really, if the Western white man has proved one thing ... it's the futility of modern society. So the have-not peoples become the haves. Even so, will that change the essential functions of the world? Will there be more love or beauty in the world ... more knowledge ... because of it?

WALKER. Probably. Probably there will be more ... if more people have a chance to understand what it is. But that's not even the point. It comes down to baser human endeavor than any social-political thinking. What does it matter if there's more love or beauty? Who the fuck cares? Is that what the Western ofay thought while he was ruling ... that his rule somehow brought more love and beauty into the world?

Oh, he might have thought that concomitantly, while sipping a gin rickey and scratching his ass ... but that was not ever the point. Not even on the Crusades. The point is that you had your chance, darling, now these other folks have theirs. [*Quietly*] Now they have theirs.

EASLEY. God, what an ugly idea.

This confrontation between the Black radical and the white liberal is symbolic of larger confrontations occurring between the Third World and Western society. It is a confrontation between the colonizer and the colonized, the slave-master and the slave. Implicit in Easley's remarks is the belief that the white man is culturally and politically superior to the Black man. Even though Western society has been traditionally violent in its relation with the Third World, it sanctimoniously deplores violence or self-assertion on the part of the enslaved. And the Western mind, with clever rationalizations, equates the violence of the oppressed with the violence of the oppressor. So that when the native preaches self-determination, the Western white man cleverly misconstrues it to mean hate of *all* white men. When the Black political radical warns his people not to trust white politicians of the left and the right, but instead to organize separately on the basis of power, the white man cries: "Racism in reverse." Or he will say, as many of them do today: "We deplore both white and Black racism." As if the two could be equated.

There is a minor element in *The Slave* which assumes great importance in a later play entitled *Jello*. Here I refer to the emblem of Walker's army: a red-mouthed grinning field slave. The revolutionary army has taken one of the most hated symbols of the Afro-American past and radically altered its meaning.[1] This is the supreme act of freedom, available only to those who have liberated themselves psychically. Jones amplifies this inversion of emblem and symbol in *Jello* by making Rochester (Ratfester) of the old Jack Benny (Penny) program into a revolutionary nationalist. Ratfester, ordinarily the supreme embodiment of the Uncle Tom Clown, surprises Jack Penny by turning on the other side of the nature of the Black man. He skillfully, and with an evasive black humor, robs Penny of all of his money. But Ratfester's actions are "moral." That is to say, Ratfester is getting his back pay; payment of a long-overdue debt to the Black man. Ratfester's sensibilities are different from Walker's. He is *blues people* smiling and shuffling while trying to figure out how to destroy the white thing. And like the blues man, he is the master of the understatement. Or in the Afro-American folk tradition, he is the Signifying Monkey, Shine, and Stagolee all rolled into one. There are no stereotypes any more. History has killed Uncle Tom. Because even Uncle Tom has a breaking point beyond which he will not be pushed. Cut deeply enough into the most docile Negro, and you will find a conscious murderer. Behind the lyrics of the blues and the shuffling porter loom visions of white throats being cut and cities burning.

Jones's particular power as a playwright does not rest solely on his revolutionary vision, but is instead derived from his deep lyricism and spiritual outlook. In many ways, he is fundamentally more a poet than a playwright. And it is his lyricism that gives body to his plays. Two important plays in this regard are *Black Mass* and *Slave Ship*. *Black Mass* is based on the Muslim myth of Yacub. According to this myth, Yacub, a Black scientist, developed the means of grafting different colors of the Original Black Nation until a White Devil was created. In *Black Mass*, Yacub's experiments produce a raving White Beast who is condemned to the coldest regions of the North. The other magicians implore Yacub to cease his experiments. But he insists on claiming the primacy of scientific knowledge over spiritual knowledge. The sensibility of the White Devil is alien, informed by lust and sensuality. The Beast is the consummate embodiment of evil, the beginning of the historical subjugation of the spiritual world.

Black Mass takes place in some prehistorical time. In fact, the concept of time, we learn, is the creation of an alien sensibility, that of the Beast. This is a deeply weighted play, a colloquy on the nature of man, and the relationship between legitimate spiritual knowledge and scientific knowledge. It is LeRoi Jones's most important play mainly because it is informed by a mythology that is wholly the creation of the Afro-American sensibility.

Further, Yacub's creation is not merely a scientific exercise. More fundamentally, it is the aesthetic impulse

gone astray. The Beast is created merely for the sake of creation. Some artists assert a similar claim about the nature of art. They argue that art need not have a function. It is against this decadent attitude toward art— ramified throughout most of Western society—that the play militates. Yacub's real crime, therefore, is the introduction of a meaningless evil into a harmonious universe. The evil of the Beast is pervasive, corrupting everything and everyone it touches. What was beautiful is twisted into an ugly screaming thing. The play ends with destruction of the holy place of the Black Magicians. Now the Beast and his descendants roam the earth. An offstage voice chants a call for the Jihad to begin. It is then that myth merges into legitimate history, and we, the audience, come to understand that all history is merely someone's version of mythology.

Slave Ship presents a more immediate confrontation with history. In a series of expressionistic tableaux it depicts the horrors and the madness of the Middle Passage. It then moves through the period of slavery, early attempts at revolt, tendencies toward Uncle Tom–like reconciliation and betrayal, and the final act of liberation. There is no definite plot (LeRoi calls it a pageant), just a continuous rush of sound, groans, screams, and souls wailing for freedom and relief from suffering. This work has special affinities with the New Music of Sun Ra, John Coltrane, Albert Ayler, and Ornette Coleman. Events are blurred, rising and falling in a stream of sound. Almost cinematically, the images flicker and fade against a heavy

backdrop of rhythm. The language is spare, stripped to the essential. It is a play which almost totally eliminates the need for a text. It functions on the basis of movement and energy—the dramatic equivalent of the New Music.

III

LeRoi Jones is the best-known and the most advanced playwright of the movement, but he is not alone. There are other excellent playwrights who express the general mood of the Black Arts ideology. Among them are Ron Milner, Ed Bullins, Ben Caldwell, Jimmy Stewart, Joe White, Charles Patterson, Charles Fuller, Aishah Hughes, Carol Freeman, and Jimmy Garrett.

Ron Milner's *Who's Got His Own* is of particular importance. It strips bare the clashing attitudes of a contemporary Afro-American family. Milner's concern is with legitimate manhood and morality. The family in *Who's Got His Own* is in search of its conscience, or more precisely its own definition of life. On the day of his father's death, Tim and his family are forced to examine the inner fabric of their lives: the lies, self-deceits, and sense of powerlessness in a white world. The basic conflict, however, is internal. It is rooted in the historical search for Black manhood. Tim's mother is representative of a generation of Christian Black women who have implicitly understood the brooding violence lurking in their men. And with this understanding, they have interposed themselves between their men and the object

of that violence—the white man. Thus unable to direct his violence against the oppressor, the Black man becomes more frustrated and the sense of powerlessness deepens. Lacking the strength to be a man in the white world, he turns against his family. So the oppressed, as Fanon explains, constantly dreams violence against his oppressor, while killing his brother on fast weekends.

Tim's sister represents the Negro woman's attempt to acquire what Eldridge Cleaver calls "ultrafemininity." That is, the attributes of her white upper-class counterpart. Involved here is a rejection of the body-oriented life of the working-class Black man, symbolized by the mother's traditional religion. The sister has an affair with a white upper-class liberal, ending in abortion. There are hints of lesbianism, that is, a further rejection of the body. The sister's life is a pivotal factor in the play. Much of the stripping away of falsehood initiated by Tim is directed at her life, which they have carefully kept hidden from the mother.

Tim is the product of the new Afro-American sensibility, informed by the psychological revolution now operative within Black America. He is a combination ghetto soul brother and militant intellectual, very hip and slightly flawed himself. He would change the world, but without comprehending the particular history that produced his "tyrannical" father. And he cannot be the man his father was—not until he truly understands his father. He must understand why his father allowed himself to be insulted daily by the "honky" types on the job;

why he took a demeaning job in the "shit-house"; and why he spent on his family the violence that he should have directed against the white man. In short, Tim must confront the history of his family. And that is exactly what happens. Each character tells his story, exposing his falsehood to the other until a balance is reached.

Who's Got His Own is not the work of an alienated mind. Milner's main thrust is directed toward unifying the family around basic moral principles, toward bridging the "generation gap." Other Black playwrights, Jimmy Garrett for example, see the gap as unbridgeable.

Garrett's *We Own the Night* takes place during an armed insurrection. As the play opens we see the central characters defending a section of the city against attacks by white police. Johnny, the protagonist, is wounded. Some of his Brothers intermittently fire at attacking forces, while others look for medical help. A doctor arrives, forced at gunpoint. The wounded boy's mother also comes. She is a female Uncle Tom who berates the Brothers and their cause. She tries to get Johnny to leave. She is hysterical. The whole idea of Black people fighting white people is totally outside of her orientation. Johnny begins a vicious attack on his mother, accusing her of emasculating his father—a recurring theme in the sociology of the Black community. In Afro-American literature of previous decades the strong Black mother was the object of awe and respect. But in the new literature her status is ambivalent and laced with tension. Historically, Afro-American women have had to be the

economic mainstays of the family. The oppressor allowed them to have jobs while at the same time limiting the economic mobility of the Black man. Very often, therefore, the woman's aspirations and values are closely tied to those of the white power structure and not to those of her man. Since he cannot provide for his family the way white men do, she despises his weakness, tearing into him at every opportunity until, very often, there is nothing left but a shell.

The only way out of this dilemma is through revolution. It either must be an actual blood revolution, or one that psychically redirects the energy of the oppressed. Milner is fundamentally concerned with the latter and Garrett with the former. Communication between Johnny and his mother breaks down. The revolutionary imperative demands that men step outside the legal framework. It is a question of erecting *another* morality. The old constructs do not hold up, because adhering to them means consigning oneself to the oppressive reality. Johnny's mother is involved in the old constructs. Manliness is equated with white morality. And even though she claims to love her family (her men), the overall design of her ideas are against Black manhood. In Garrett's play the mother's morality manifests itself in a deep-seated hatred of Black men; while in Milner's work the mother understands, but holds her men back.

The mothers that Garrett and Milner see represent the Old Spirituality—the Faith of the Fathers of which DuBois spoke. Johnny and Tim represent the New Spiri-

tuality. They appear to be a type produced by the upheavals of the colonial world of which Black America is a part. Johnny's assertion that he is a criminal is remarkably similar to the rebel's comments in Aimé Césaire's play *Les Armes miraculeuses* (*The Miraculous Weapons*). In that play the rebel, speaking to his mother, proclaims: "My name—an offense; my Christian name—humiliation; my status—a rebel; my age—the stone age." To which the mother replies: "My race—the human race. My religion—brotherhood." The Old Spirituality is generalized. It seeks to recognize Universal Humanity. The New Spirituality is specific. It begins by seeing the world from the concise point of view of the colonialized. Where the Old Spirituality would live with oppression while ascribing to the oppressors an innate goodness, the New Spirituality demands a radical shift in point of view. The colonialized native, the oppressed must, of necessity, subscribe to a *separate* morality. One that will liberate him and his people.

The assault against the Old Spirituality can sometimes be humorous. In Ben Caldwell's play *The Militant Preacher*, a burglar is seen slipping into the home of a wealthy minister. The preacher comes in and the burglar ducks behind a large chair. The preacher, acting out the role of the supplicant minister, begins to moan, praying to De Lawd for understanding.

In the context of today's politics, the minister is an Uncle Tom, mouthing platitudes against self-defense. The preacher drones in a self-pitying monologue about

the folly of protecting oneself against brutal policemen. Then the burglar begins to speak. The preacher is startled, taking the burglar's voice for the voice of God. The burglar begins to play on the preacher's old-time religion. He *becomes* the voice of God insulting and goading the preacher on until the preacher's attitudes about protective violence change. The next day the preacher emerges militant, gun in hand, sounding like Reverend Cleage in Detroit. He now preaches a new gospel—the gospel of the gun, an eye for an eye. The gospel is preached in the rhythmic cadences of the old Black Church. But the content is radical. Just as Jones inverted the symbols in *Jello*, Caldwell twists the rhythms of the Uncle Tom preacher into the language of the new militancy.

These plays are directed at problems within Black America. They begin with the premise that there is a well-defined Afro-American audience. An audience that must see itself and the world in terms of its own interests. These plays, along with many others, constitute the basis for a viable movement in the theater—a movement which takes as its task a profound reevaluation of the Black man's presence in America. The Black Arts Movement represents the flowering of a cultural nationalism that has been suppressed since the 1920s. I mean the "Harlem Renaissance"—which was essentially a failure. It did not address itself to the mythology and the lifestyles of the Black community. It failed to take roots, to link itself concretely to the struggles of that community, to become its voice and spirit. Implicit in the Black

Arts Movement is the idea that Black people, however dispersed, constitute a *nation* within the belly of white America. This is not a new idea. Garvey said it and the Honorable Elijah Muhammad says it now. And it is on this idea that the concept of Black Power is predicated.

Afro-American life and history is full of creative possibilities, and the movement is just beginning to perceive them. Just beginning to understand that the most meaningful statements about the nature of Western society must come from the Third World of which Black America is a part. The thematic material is broad, ranging from folk heroes like Shine and Stagolee to historical figures like Marcus Garvey and Malcolm X. And then there is the struggle for Black survival, the coming confrontation between white America and Black America. If art is the harbinger of future possibilities, what does the future of Black America portend?

1 In Jones's study of Afro-American music, *Blues People*, we find the following observation: "Even the adjective *funky*, which once meant to many Negroes merely a stink (usually associated with sex), was used to qualify the music as meaningful (the word became fashionable and is now almost useless). The social implication, then, was that even the old stereotype of a distinctive Negro smell that white America subscribed to could be turned against white America. For this smell now, real or not, was made a valuable characteristic of 'Negro-ness.' And 'Negro-ness,' by the fifties, for many Negroes (and whites) was the only strength left to American culture."

Any Day Now: Black Art and Black Liberation
Ebony, August 1969

I was born by the river in a little old tent,
and just like the river, I've been running ever since.
It's been a long time, but I know change is gonna come
—Sam Cooke

We bear witness to a profound change in the way we now see ourselves and the world. And this has been an ongoing change. A steady, certain march toward a collective sense of who we are, and what we must now be about to liberate ourselves. Liberation is impossible if we fail to see ourselves in more positive terms. For without a change of vision, we are slaves to the oppressor's ideas and values—ideas and values that finally attack the very core of our existence. Therefore, we must see the world in terms of our own realities.

Black Power, in its most fundamental sense, stands for the principles of Self-Definition and Self-Determination. Black Power teaches us that we must have ultimate control over our own lives. It teaches us that we must make a place on this Earth for ourselves, and that we must construct, through struggle, a world that is compatible with our highest visions.

This was the gut essence of the Black Power philosophy before the political butchers and the civil rights hustlers got into the game, confusing everybody and the issues. Black Power is essentially a nationalistic con-

cept; it speaks to the suppressed need of Afro-Americans for true liberation, for Nationhood. The forerunners of the current movement were such nineteenth-century thinkers as David Walker, Edward Blyden, and Martin Delany. The movement takes its revolutionary zeal from Gabriel Prosser and Nat Turner. It takes its Third World outlook from W. E. B. DuBois, Marcus Garvey, Malcolm X, and Frantz Fanon. And on its weaker side, it takes its economic and institutional philosophy from Booker T. Washington. Therefore, when Brother Stokely Carmichael invoked the slogan "Black Power" on the Meredith March, it was these voices speaking through him.

Now along with the Black Power movement, there has been developing a movement among Black artists. This movement we call the Black Arts. This movement, in many ways, is older than the current Black Power movement. It is primarily concerned with the cultural and spiritual liberation of Black America. It takes upon itself the task of expressing, through various art forms, the Soul of the Black Nation. And like the Black Power Movement, it seeks to define the world of art and culture in its own terms. The Black Arts Movement seeks to link, in a highly conscious manner, art and politics in order to assist in the liberation of Black people. The Black Arts Movement, therefore, reasons that this linking must take place along lines that are rooted in an Afro-American and Third World historical and cultural sensibility. By "Third World," we mean that we see our struggle in the context of global confrontations

occurring in Africa, Asia, and Latin America. We identify with all of the righteous forces in those places which are struggling for human dignity.

Lately, Black artists have been concerned with the development, for lack of a better term, of a "Black Aesthetic." Aesthetic sounds like some kind of medical term. It might just as well be for all that its dictionary definition tells us: "Aesthetic: 1) A branch of philosophy relating to the nature of forms of beauty, especially found in the fine arts. 2) Study of the mental and emotional responses to the beauty in art, nature, etc." (Standard College Dictionary.)

For the most part, this definition is worthless. What the Western white man calls an "aesthetic" is fundamentally a dry assembly of dead ideas based on a dead people; a people whose ideas have been found meaningless in light of contemporary history. We need new values, new ways of living. We need a new system of moral and philosophical thought. Dig: There is nothing in the above quoted definition about *people*. It is a cold, lifeless corpse they speak of; the emanations of a dead world trying to define and justify itself.

Therefore, today we bear witness to the moral and philosophical decay of a corrupt civilization. Europe and America are the new Babylons. Today, we see white artists wallowing in the sudden discovery of the body, of sex. These hypocritical puritans now play with themselves like newborn babies. They have suddenly discovered the body which, for centuries, they denied existed. Art and the body. Sexploitation. Andy Warhol madness. America

has become one great big dirty movie. Like suddenly sex, one of man's most natural urges, has become controversial; or at least, they would have us believe so. What's so controversial about sex? Nothing, we know.

I raise these questions to illustrate the impasse that Western art has reached. They fall back on the sex thing because they are unable to deal with the political, spiritual, and cultural liberation of Man. They are unable within the confines of even their ideas of art to deal with the real issues confronting man today. And the most important of which is the liberation of the majority of mankind. So they steal and suck Black energy, an energy which in the slop jars of their minds they distort and corrupt in their own sick images.

And backed up by a powerful and oppressive political system, he tries to force Black people to measure up to his standards. Thus, we are constantly forced to see ourselves through white eyes. We are made to evaluate our innermost impulses against his. And in the process, we do ourselves great spiritual and psychological harm. The Black Arts Movement seeks to give a total vision of ourselves. Not the split vision that DuBois called the "double consciousness": "this sense of always looking at one's self through the eyes of others, of measuring one's soul by the tape of a world that looks on in amused contempt and pity. One ever feels his two-ness,—an American, a Negro; two souls, two thoughts, two unreconciled strivings; two warring ideals in one dark body, whose dogged strength alone keeps it from being torn asunder."

These words are from *The Souls of Black Folk* which was published in 1903. Now, in 1969, DuBois's sons and daughters in the Black Arts Movement go forth to destroy the "double consciousness," go forth to merge these "warring ideals" into One Committed Soul integrated with itself and taking its own place in the world. Can you dig it?

But this is no new thing. It is the road that all oppressed peoples take en route to total liberation. In the history of Black America, the current ideas of the Black Arts Movement can be said to have their roots in the so-called Negro Renaissance of the 1920s. The twenties were a key period in the rising historical and cultural consciousness of Black people. This period grooved with the rise of Garvey's Black Nationalism, danced and made love to the music of Louis Armstrong, Bessie Smith, Jelly Roll Morton, King Oliver, Perry Bradford, Fats Waller, and the Holy Father, Duke Ellington. There was a flowering of Black poets, writers, and artists. And there was the ascendancy of hip, blues-talking Langston Hughes who came on singing songs about Africa, Haiti, and Harlem:

Droning a drowsy syncopated tune,
Rocking back and forth to a mellow croon,
I heard a Negro play.
Down on Lenox Avenue the other night
By the pale dull pallor of an old gas light
He did a lazy sway....

He did a lazy sway....
To the tune o' those Weary Blues.

There were other writers of that period: Claude McKay, Jean Toomer, James Weldon Johnson, Countee Cullen ... But Langston best personifies the Black artist who is clearly intent upon developing a style of poetry which springs forcefully and recognizably from a Black lifestyle; a poetry whose very tone and concrete points of reference is informed by the feelings of the people as expressed in the gospel and blues songs.

It is here that any discussion of a Black aesthetic must begin. Because Black music, in all of its forms, represents the highest artistic achievement of the race. It is the memory of Africa that we hear in the churning energy of the gospels. The memory of the Motherland that lingers behind the Christian references to Moses, Jesus, and Daniel. The Black Holy Ghost roaring into some shack of a church in the South, seizing the congregation with an ancient energy and power. The Black Church, therefore, represents and embodies the transplanted African memory. The Black Church is the Keeper of that Memory, the spiritual bank of our almost forgotten visions of the Homeland. The Black Church was the institutionalized form that Black people used to protect themselves from the spiritual and psychological brutality of the slave-masters. She gave us a music, a literature, and a very valid and essential poetry. And when she ceased to be relevant, for some of us, we sang the blues:

"They call it stormy Monday, but Tuesday's just as bad; call it stormy Monday, but Tuesday's just as bad. Wednesday's worse, and Thursday's also sad ..."

At the pulsating core of their emotional center, the blues are the spiritual and ritual energy of the church thrust into eyes of life's raw realities. Even though they appear to primarily concern themselves with the secular experience, the relationships between males and females, between boss and worker, between nature and Man, they are, in fact, extensions of the deepest most pragmatic spiritual and moral realities. Even though they primarily deal with the world as flesh, they are essentially religious. Because they finally celebrate life and the ability of man to control and shape his destiny. The blues don't jive. They reach way down into the maw of the individual and collective experience. Sonny Terry and Brownie McGhee sing: *"If you lose your money, please don't lose your mind; if you lose your woman, please don't mess with mine."*

Taken together, the blues represent an epic cycle of awesome propositions—one song (poem) after the other expressing the daily confrontations of Black people with themselves and the world. They are not merely entertainment. They act to clarify and make more bearable the human experience, especially when the context of that experience is oppressive. A man that doesn't watch his "happy home" is in a whole world of trouble. Therefore, the blues singer is teaching an ethical standard in much the same way as the poet. Only the psychic strength of

most of the blues singers is oftentimes more intensely focused than that of the poets. We must often strain for images like: *"I walked out in the Milky Way and I reached for a star. I looked across the cosmic way and my lover, she wasn't very far ..."*

That's Jimmy Reed. As poetry, the blues act to link Man to a past informed by the Spirit. A past in which art served as a means of connecting our ancestors with the unknown psychic forces which they knew to exist in the Universe. Yeah. Forces which they somehow felt were related to the natural operation of the Universe. *(He's a Deep Sea Diver with a stroke that can't go wrong.)* The blues are a deep-down thing, always trying to get to the nitty-gritty of the human experience.

Therefore, no matter how you cut it, the blues and the people who create them are the Soul Force of the race, the emotional current of the Nation. And that is why Langston Hughes and Ralph Ellison based their aesthetic on them. The Black Arts Movement strives for the same kind of intimacy with the people. It strives to be a movement that is rooted in the fundamental experiences of the Nation.

The blues singer is not an alienated artist moaning songs of self-pity and defeat to an infidel mob. He is the voice of the community, its historian, and one of the shapers of its morality. He may claim to speak for himself only, but his ideas and values are, in fact, merely expressions of the general psychology of his people. He is the bearer of the group's working myths, aspirations,

and values. And like the preacher, he has been called on by the Spirit to rap about life in the sharpest, the harshest terms possible. Also like the preacher, he may have gotten the calling early in life. He may have even sung in the church like Ray Charles and James Brown.

It is the ultimate urge to communicate the private pain to the collective that drives and pushes the blues singer from place to place, from job to job, from one fast-moving freight train to the other. All kinds of cities and people moving through the blues experience. All kinds of human tragedies and circumstances find their way into the blues singer's repertoire. It is all about feeling. All about people. All about Truth.

Contemporary Black music and the living folklore of the people are, therefore, the most obvious examples of the Black aesthetic. Because these forms are the truest expressions of our pain, aspirations, and group wisdom. These elements decidedly constitute a culture. And a culture expresses a definite feeling about the world. Otis Redding, Sam Cooke, Little Willie John, Blind Lemon, Bessie Smith, Billie Holiday, Charlie Parker, Coleman Hawkins, Eric Dolphy, and John Coltrane are, in the minds of Black people, more than entertainers. They are the poets and philosophers of Black America. Each of these artists devoted his life to expressing what Du-Bois referred to as the "Souls of Black Folk." They, along with the Black Church, are the keepers of our memory, the tribal historians, soothsayers, and poets. In them, more so than in literature, we find the purest and most

powerful expression of the Black experience in America. These artists have set the standards, and the current movement attempts to meet them and, where possible, to create new and more demanding ones.

So when *we* speak of an aesthetic, we mean *more* than the process of making art, of telling stories, of writing poems, of performing plays. We also mean the destruction of the white thing. We mean the destruction of white ways of looking at the world. For surely, if we assert that Black people are fighting for liberation, then everything that we are about, as people, somehow relates to it.

Let me be more precise: When artists like LeRoi Jones, Quincy Troupe, Stanley Crouch, Joe Goncalves, Etheridge Knight, Sonia Sanchez, Ed Spriggs, Carolyn Rodgers, Don L. Lee, Sun Ra, Max Roach, Abbey Lincoln, Willie Kgositsile, Arthur Pfister … assert that Black Art must speak to the lives and the psychic survival of Black People, they are not speaking of "protest" art. They are not speaking of an art that screams and masturbates before white audiences. That is the path of Negro literature and civil rights literature. No, they are not speaking about that kind of thing, even though that is what some Negro writers of the past have done. Instead, they are speaking of an art that addresses itself directly to Black people; an art that speaks to us in terms of our feelings and ideas about the world; an art that validates the positive aspects of our lifestyle. Dig: An art that opens us up to the beauty and ugliness within us; that makes us understand our condition and each other in a more profound manner;

that unites us, exposing us to our painful weaknesses and strengths; and finally, an art that posits for us the Vision of a Liberated Future.

So the function of artistic technique and a Black aesthetic is to make the goal of communication and liberation more possible. Therefore, Black poets dig the blues and Black music in order to find in them the means of making their address to Black America more understandable. The Black artist studies Afro-American culture, history, and politics and uses their secrets to open the way for the brothers with the heavy and necessary political rap. We know that art alone will not liberate us. We know that culture as an abstract thing within itself will not give us Self-Determination and Nationhood. And that is really what we all want, even though we fail often to admit it openly. We want to rule ourselves. Can you dig it? I know you can.

But a cultureless revolution is a bullcrap tip. It means that in the process of making the revolution, we lose our vision. We lose the soft, undulating side of ourselves—those unknown beauties lurking rhythmically below the level of material needs. In short, a revolution without a culture would destroy the very thing that now unites us; the very thing we are trying to save along with our lives. That is, the *feeling* and *love-sense* of the blues and other forms of Black music. The *feeling* of a James Brown or an Aretha Franklin. That is the *feeling* that unites us and makes it more possible for us to move and groove together, to do whatever is necessary to liberate ourselves.

John Coltrane's music must unquestionably be a part of any future revolutionary society, or something is diabolically wrong with the fools who make the revolution. A revolution that would have Leonard Bernstein, Bobby Dylan, or the Beatles at the top of its cultural hierarchy would mean that in the process of making the revolution, the so-called revolutionaries had spiritually murdered Black people. (Bobby Seale are you listening?) A future society without the implied force and memory of Bessie Smith, Charlie Parker, Sun Ra, Cecil Taylor, Pharoah Sanders, and Charlie Mingus is almost inconceivable.

The artists carry the past and future memory of the race, of the Nation. They represent our various identities. They link us to the deepest, most profound aspects of our ancestry. Charlie Parker was a genius and an oppressed Black man. His is certainly a memory worth fighting for, as is the memory of Malcolm X, King, DuBois, Garvey, Fanon, Richard Wright, Jean Toomer, Claude McKay, Conrad Kent Rivers, Henry Dumas (killed by a pig in a New York subway), Booker T. Washington (him too), Cinque, Nat Turner, Denmark Vesey, Lead Belly, Stagolee, Shine, the Signifying Monkey, Sojourner Truth, Frederick Douglass, Harriet Tubman . . . and all of our Mothers and Fathers.

The Black Arts Movement is rooted in a spiritual ethic. In saying that the function of art is to liberate Man, we propose a function for art which is now dead in the West and which is in keeping with our most ancient traditions

and with our needs. Because, at base, art is religious and ritualistic; and ritual moves to liberate Man and to connect him to the Greater Forces. Thus Man becomes stronger psychically, and is thus more able to create a world that is an extension of his spirituality—his positive humanity. We say that the function of art is to liberate Man. And we only have to look out of the window to see that we need liberation. Right on, Brothers. And God Shango, help us!

This is what's on Amear Baraka's (LeRoi Jones) mind. He could have been a pawed-over genius of the white literary establishment. But he peeped that they were dead, and that they finally had nothing to give—the future ultimately did not include them. It was LeRoi who first used the term "Black Art" in a positive sense. In the Western worldview, it is connected with the "evil," "dark" forces of witchcraft and demonology. It was LeRoi who first shifted and elevated its meaning, giving it new significance in the context of a Black aesthetic.

In a poem entitled "Black Art" he sings that Poem is the Black nation:

We want a black poem. And
a Black World.
Let the world be a Black Poem

Therefore, the Poem comes to stand for the collective consciousness of Black America—the will toward Nationhood which is the unconscious motivation in back

of the Black Power movement. It comes to stand for a radical reordering of the nature and function of both art and the artist.

But LeRoi is only one part of the developing consciousness. Let's check out some other Brothers and Sisters. Here is James Brown reminding us of our past. The hit song "There Was a Time" traces the history of a people through their dances, and achieves in the process something of a rhythm and blues epic poem:

> *There was a dance—*
> *Dig this:*
> *There was a dance*
> *I used to do*
> *They call the Mash Patater.*
>
> *There was a day.*
> *Now dig this:*
> *There was a dance.*
> *Now dig this:*
> *They call the Jerk,*
> *Everybody relax and watch me work*

The aesthetic is both the activity and the memory of the activity. The movement, the energy that is actual and real. Not merely what happens on the page. Quoting these lyrics hardly does justice to Brown's genius. He invokes dances like the Camel Walk and the Boogaloo. Each dance conjuring up a definite feeling and memory.

Black poetry is best understood, as the powerful force that it is, when it is recited and danced.

And in a bar called the Shalimar in Harlem, on Seventh Avenue, Gylan Kain understands that there is:

a sense of coolness
at midday
as passersby
 pass in
 an' out
a bar they call
The Shalimar
day blackens into night
and night blackens into day
 and soul

 blazes into flames/of
PINKS and GREENS and YELLOWS and REDS
 and BLUES—
and BROWN and OPALS and SOUNDS
 SHADOWS—
protrude outward
into alligator shoes/leopard skins
funny kind of hats that slant
downward and sideward
that in some funny kind of way
become ultra hip
the voodoo, who do
what you don't dare do people

Dig on Carolyn Rodgers singing about the kind of poem she wants:

I want a poem for the eternal Red, Big Red, dead Red,
a-live Red in our hearts, his ending,
our beginning, yeah
> *I want a poem that don't be cryin*
> *or scream/preachin/rappin*
> *for the end of scream/preachin/rappin*
> *or protestin for the cause of protestin*
> *or lyin for the white pigs,*
>> *I want a mean poem.*

Ed Spriggs wants magic to happen:

witch doctor
come uptown
come tennis-shoed
come sucking on a short neck
come holding onto a tit in mt morris pk
come lick sweet on some caldonia's ears
(where ever you find them)
come hear what black rose hymns
into the altar of our afro'd ears . . .
do sukey jumps or the boogaloo but come on
turkey us cats in hero bones
shoot your shit from starless roof
spread magic substances
pour it on our hymnals

on our tenement radiator pulse
candle the interior our mammy's womb
fatten it with roots of sassafras
witch doctor come up here

Arthur Pfister uses street rhythms to get this:

> *Mouths ain't guns*
> *& tongues ain't missiles.*
> *Eyes ain't suns*
> *& hairs ain't thistles.*
> *Poems ain't knives, or grenades to sling,*
> *but dig me brother,*
> > *we gon'*
> > > *do our thing*

Singer Chuck Jackson sees "blue shadows" falling all over town; and Smokey Robinson, with pain in his voice, tells his baby about tracks of his tears and the smile that is not really there. Marvin Gaye and Tammi Terrell affirm the love that we have for each other, singing, "You're all I need to get by." Jerry Butler teaches us that Only the Strong Survive. The Last Poets sing and dance power poems about Black love, the Third World, and Black Liberation. Willie Kgositsile reminds us:

> *What does my hunger*
> *Have to do with a gawdamn poem?*
> *THIS WIND YOU HEAR IS THE BIRTH OF MEMORY.*

WHEN THE MOMENT HATCHES IN TIME'S WOMB
THERE WILL BE NO ART TALK. THE ONLY POEM
YOU WILL HEAR WILL BE THE SPEARPOINT
PIVOTED IN THE PUNCTURED MARROW OF THE
VILLAIN; THE TIMELESS NATIVE SON DANCING
LIKE CRAZY TO THE RETRIEVED
 RHYTHMS OF DESIRE FADING INTO MEMORY.

The Black Arts Movement preaches that liberation is inextricably bound up with politics and culture. The culture gives us a revolutionary moral vision and a system of values and a methodology around which to shape the political movement. When we say "culture," we do not merely mean artistic forms. We mean, instead, the values, the lifestyles, and the feelings of the people as expressed in everyday life. The total liberation of Blues People cannot be affected if we do not have a value system, a point of reference, a way of understanding what we see and hear every day around us. If we do not have a value system that is, in reality, more moral than the oppressor's, then we cannot hope to change society. We will end up taking each other off, and in our confusion and ignorance, calling the murders of each other revolutionary. A value system helps us to establish models for Black people to emulate; makes it more possible for us to deeply understand our people, and to be understood by them.

Further, the Black Arts Movement proposes a new "mythology." What musician-poet Jimmy Stewart calls a

"Black Cosmology," a Black Worldview that is informed by the living Spirit. According to Stewart, such a world-view would make easier and more natural the shaping of the Black artistic, cultural, and political forms. This idea has fantastic implications for religion, as the Honorable Elijah Muhammad and Detroit's Reverend Albert Cleage have demonstrated.

Like can you dig it: We have been praying to the wrong God. And who is God anyway but the awesomely beautiful forces of the Universe? The Black Sun exploding semen into Her dark body. Your ancestors are the Gods who have actually walked this planet. Those who have tried to liberate us. Nat Turner, Harriet Tubman, Malcolm X, they are surely Gods. They preached Black Liberation. And Black Liberation is far more important than some Alice-in-Wonderland Heaven. Black Art must sing the praises of the true Gods of the planet. We don't need any soulless Hebrew God. We need to see ourselves reflected in our religions. For prayer is poetry; and like poetry it acts to reinforce the group's vision of itself. If that vision is rooted in a hypocritical alien force, we do ourselves great psychic and psychological harm by adhering to it. For example, one of the first things the Algerians did when they began to fight the French was to cease allowing the colonial authorities to conduct their marriage ceremonies.

Like Black Art, Black religion should be about strengthening group unity and making radical change. If your minister is not, in some way, engaged in the job

of achieving Black freedom, he is a con man. Cut him loose quick.

The text of my sermon is the Life and Death of Charlie Parker. People loved him and called him Bird. His life was confusion in the midst of artistic creation. In some ways, you could say he was a sinner. But like us he lived and did the best that he could do under the circumstances. And after my sermon, Brother Sun Ra will perform some songs about the nature of the universe; and after that we will have some words from the Self-Defense Committee.

Religion, therefore, like politics, can embrace all of the ideological features of the liberation struggle. What is needed, however, is a change of references. A hippy Jesus won't do. A change of references is needed in Black popular music also. Like: We can't go into the future singing "Who's making love to your old lady" or "It's your thang, do with it what you wanna do."

It is the task of the Black artist to place before his people images and references that go beyond merely reflecting the oppression and the conditions engendered by the oppression. Don't condemn the people for singing the blues. Write a blues that takes us to a more meaningful level of consciousness and aspiration. But also understand the realities of the human condition that are posed by the blues. Take the energy and the feeling of the blues, the mangled bodies, the broken marriages, the moaning nights, the shouting, the violence, the love cheating, the lonely sounding train whistles, and shape these into an art that stands for the spiritual helpmate of the Black

Nation. Make a form that uses the Soul Force of Black culture, its lifestyles, its rhythms, its energy, and direct that form toward the liberation of Black people. Don't go off playing Jimi Hendrix or something like that. Respect and understand the culture. Don't exploit it.

Put it into meaningful institutions that are run and controlled by Black people with a vision. What Amear is trying to do in Newark. What Clarence Reed and the beautiful young Brothers of the Harlem Youth Federation are trying to do at the Black Mind in Harlem. What Jacques and Cecilia and other Liberators of the National Black Theatre work hard at daily. Give to the culture temples like the East Wind where you can see the Last Poets. Build something like Gaston Neal's school in Washington, DC. Let us see theaters like the new Lafayette springing up wherever Black people live and work. Construct Black universities like Abdul, A. B. Spellman, and Vincent Harding are trying to do. Because these attempts at building Black institutions are not merely *cultural* in the narrow sense of that word. They are finally about the physical and spiritual survival of Black America. In the context of our struggle *here*, they are as important as the gun.

Yeah. While on the subject of the gun. If de war comes, and, dis being America, it probably will—whose images and songs will flicker on the film of your brain: Billie Holiday's or Janis Joplin's? Whose pain and suffering whistles past your ears in the gas-filled night, Malcolm X's or Joseph Stalin's? Check it out … (This is mean, ain't it?)

The Black Arts Movement supplies the political brothers with an arsenal of feelings, images, and myths.

Brother Rap: *This is the role of culture. Don't let the political Brothers in the naturals and blue dashikis hang you up. Everybody who is aware knows that this thing goes beyond hairstyles and African clothing. The most brainwashed brother on the street is hip to that. That's why some of the meanest, most potentially revolutionary niggers still wear processes.*

The new references of clothing and hair are essentially visions of ourselves perfected; they are signposts on the road to eventual Self-Determination. For a Sister to wear her hair natural asserts the sacred and essentially holy nature of her body. The natural, in its most positive sense, symbolizes the Sister's willingness to determine her own destiny. It is an act of love for herself and her people. The natural helps to psychologically liberate the Sister. It prepares her for the message of a Rap Brown, a Robert Williams, a Huey Newton, a Maulana Karenga. The Sister's natural helps to destroy the "double consciousness" DuBois spoke of. It gives her what Eldridge Cleaver calls a "Unitary Image" of herself. That is, she comes to see herself as a more spiritually total person.

If Black Revolutionary Cultural Consciousness is perverted by jive Negro hustlers and Madison Avenue freaks, it is our job to illustrate how that very perversion is consistent with the nature of the capitalistic, colonialistic, and imperialistic monsters that now rule the planet.

To merely point out to Black people the economic and political nature of our oppression is not enough. Why is it not enough? It is so because people are *more* than just the sum total of economic and political factors. Man must exist on a more cosmic plane than that. This is what Cecil Taylor, Phil Cohran, Aretha Franklin, Milford Graves, Abdul Rahman, James Snead, Loften Mitchell, Evan Walker, Ed Bullins, Ron Milner, Maya Angelou, Jacob Lawrence, Tony Norther, Charlie Fuller, Romare Bearden, Eleo Pomare, Judy Dearing, John Parks, and all of the names I have forgotten teach us. Yeah.

The Blues God knows that he will cease to exist if his people cease to exist. He knows that being Black and Beautiful is not enough. He knows that the oppressor cares nothing about our beauty. And I'm certain that He will back me up in this. Right Stanley and Black Arthur?

This is what the Black Arts Movement is all about. What I believe to be its most vital core. However, there *are* people out there bullcrapping, but that don't matter—the Black Boogaloo will blow them away. What we got to do is to dig into this thing that tugs at our souls—this blue yearning to make a way of our own.

Black people you are Black Art. You are the poem, as Amear Baraka teaches us. You are Dahomey smile. You are slave ship and field holler. You are Blues and Gospel and Be-Bop and New Music. You are Carolyn's poem, and Eleo Pomare's dance. You are Buddy Bolden's memory; you heard him play in Funky Butt Hall and Preservation Hall and in

Congo Square. You are both memory and flesh. Black Liberation to you Baby. Hey Now!

Black Liberation for the ditty-bopping hip ones; for all of the righteous sinners and hustlers; for Chaka Zulu and Honky Tonk Bud, the hip cat's stud. Black Liberation for Cinque, for Bo Diddley, for Bobby Hutton and James Powell. Black Liberation for William L. Dawson, Albert Murray, Ralph Ellison, Margaret Walker, Rosa Guy, John Clarke, John Killens, James Brown, James Baldwin; for Barbecue Bob and Big Fat Fannie; for Shine and Sugar Ray Robinson; for the Signifying Monkey and Kid Gavilán and Kid Chocolate; for Jack Johnson and High John the Conqueror. Black Liberation for Otis Redding and Wilson Pickett, for Jerry Butler, for Joe Louis, for Roy Campanella, for Helen and Malik, for Marybelle and Jeanette. Black Liberation for our unknown Fathers and your Mammy's Mammy; for ashy legs and early trim, for hopping freight trains, for the Hannibals and the Adefunmis and the Ahmeds and the Paul Robesons and the Ben Davises and the Max Stanfords and the Huey Newtons. Black Liberation for all political prisoners everywhere.

Right on. Black Liberation for the sea deaths and the chains, for long stretches of desert and pyramids, for drums, for folk tales, and the hot breathing earth, and the spiraling Father Snake and the Primeval Sperm. Black Liberation to you Baby—Check out everybody's political program carefully. Black Liberation for cotton death, for Emmett Till death, for Mack Parker death, for Leonard Deadwyler death, Medgar Evers death, for Malcolm death; Black Liberation for Mamma and Evelyn and Charles and Melvin and Robbie

and Joe and Howard and Charlie and Marybelle and Rose and Stanley and Ace and Martha and Sam and Carol and Frostie and Gerrie, and for all of my various families.

So the Blues God spoke to me, told me to hip you to what you have always secretly known. Listen carefully to the following: This is the death of the white lie that our ancestors prophesied. This is the death of the "double consciousness." Listen: under the songs and the moaning night, they plotted their deaths and worked juju on the Beasts; they spoke to us and fortified us against their insane machinations; they plotted his death under the spirituals and the blues; they invoked the Future Memory which is us, and it is to that Memory that we dance and fight and sing.

They invoked the Future Memory while baring their behinds to cracker whips and jackboots. They were visionaries and warriors; they were Niggers and Toms. They were mean Poppa Stoppas. They were pimps and prostitutes. They were railroad men and mack daddies. They were college presidents and porters. They were mucked-up intellectuals and exploited workers, gun-toting ministers, and lolligagging mommas and numbers runners, and shuffling waiters, and drifters.

They were loud and raunchy, macking in dark corners. They were invisible men, sliding into putrid sewers of the mind. They were doctors and con men, running the murphy on lonely old ladies in mourning shawls. Were high yellow debutants and mulatto clarinet players. They were Sunday tea and the Rinky Dinks and the Jack and Jills and the Elks and the Masons and jackleg preachers and Seventh Day Ad-

ventists and Baptists and Methodists and Holy Roller and Sanctified. They wore wigs and dayglow drawers. Moved to Lincoln Drive and to Mobile and to Chicago and to Harlem and to Paris. They were an oppressed Nation in the Neon Diaspora (thank you, David). They worked in the post offices and sent their daughters and sons to Negro colleges. And we love them. And we love them. And we will struggle and dedicate our lives to them (thank you Marvin Gaye and Tammi). And we love them, even though sometimes we stabbed and shot each other for flimsy dimes, falling on the wine-stained pavements; even though we shot shit into our Black arms, dying our sag deaths in funky hallways, in penthouses, in the Rivieras of aristocratic old faggots and bitches. They were Big Daddy and Big Momma. And we love them, even though sometimes we did not know it.

ALL PRAISES DUE TO THE BLACK MAN.
SHO' NUFF, CHILD....

New Grass / Albert Ayler
The Cricket: Black Music in Evolution, no. 4, 1969

Personnel: Albert, tenor sax; Call Cobbs, piano, electric harpsichord, and organ; Bill Folwell, electric bass; Pretty Purdie, drums; Burt Collins, Joe Newman, trumpets; Seldon Powell, tenor sax and flute; Buddy Lucas, baritone sax; Garnett Brown, trombone

Albert Ayler is one of the driving geniuses of the Music. He has clearly put forth a definite sound; a different and fascinating way of thinking about the world as sound; as movement; as the ghostly memory of the Spiritual Principle. Albert's sound at its best is the field holler and the shout stretched like a piercing shaft from the Alabama cotton fields to New York, and on into some cosmic world of strange energies. At his best, Albert's voices buzz and hum with awesome deities.

When most of us first heard Albert, he really blew our minds, opening us up to new possibilities not only in music but in drama and poetry as well. He was coming straight out of the Church and the New Orleans funeral parades. He had all kinds of Coon songs in his horn. He had compressed, in terms of pitch, all of the implied cycles in the blues continuum. His thrust was shattering. So that we must acknowledge that anything we say about this album must be seen against Albert's fantastic possibilities.

But lately Albert's music seems to be motivated by

forces that are not at all compatible with his genius. There is even a strong hint that the brother is being manipulated by Impulse! Records. Or is it merely the selfish desire for popularity in the American sense?

At any rate, this album is a failure. It attempts to unite the rhythm and blues dynamic with the energy dynamic of Ayler. But in attempting to unite the two styles certain very fundamental things have been overlooked. First, rhythm and blues is rooted in a popular tradition which has allowed for innumerable innovations in and of itself. It is a tradition that demands respect. Men like Junior Walker demand respect. Because like Bird, they are masters of a particular form. Therefore, any contemporary musician who attempts to use R & B elements in his music should check out the masters of that form.

Like it's not too cool to get to the Rolling Stones or the Grateful Dead to learn things that your old man can teach you. And this is the feeling that I get from listening to *New Grass*. I mean the direct confrontation with experience as *lived* by the artist himself is not there. And this is a painful thing for me to say 'cause I have always dug Albert. I know what the brother is trying to do. But his procedure is fucked up.

The rhythm on this album is shitty. There are no shadings, no implied values beyond the stated beat. The guitar is shitty. Most of the singing is shitty, especially the songs "Heart Love" and "Everybody's Movin'." The Sister sounds like she is straining, trying to find some soul in a dead beat. There are no kinds of nuances on

the drums. Hard rock, death chatterings. Albert should check out Junior Walker's band, or Bobby Blue Bland's rhythm section. He should dig the very long version of James Brown's "There Was a Time." He should note the heavy spiritual blueness in the bass guitar. He should dig how the rhythm and blues people embellish the beat, how they use space.

All this information is immediate. Most of the good bands come through the Apollo. This is where the discovery must take place, not in the context of white rock. This album strains at everything, even social consciousness.

But Albert's attempt is fundamentally correct. It just must be focused sharper. The music must find ways of reaching into the pulse of the people; ways of taking ordinary elements out of their lives and reshaping them according to new principles. In this procedure, therefore, the music moves us toward national unity and spiritual unity. A Unity Music. A music that is so total, so fully informed by a Black ethos that it meets a more collective and less specialized need. Music can be one of the strongest cohesives toward consolidating the Black Nation. The music will not survive locked into bullshit categories. James Brown needs to know Albert Ayler, Sun Ra, Cecil Taylor, and Pharoah Sanders. I would like to see the Dells ("Stay in My Corner"), with Pharoah or Archie Shepp. Implied here is the principle of artistic and national unity; a unity among musicians, our heaviest philosophers, would symbolize and effect a unity in larger cultural and political terms. Further, there should be

more attempts to link the music to other areas of the Black Arts Movement.

LIKE: REVOLUTIONARY CHOREOGRAPHERS LIKE ELEO POMARE, JOHN PARKS, JUDY DEARING, TALLEY BEATTY SHOULD BE CHECKING OUT CECIL TAYLOR'S MUSIC WHICH IS HEAVILY POSITED ON DANCE CONCEPTS.

HOW DOES POETRY AND MUSIC OPERATE IN THE CONTEXT OF POLITICAL AND RELIGIOUS GATHERINGS?

PHAROAH NEEDS A TEMPLE.
SUN RA IS A BEAUTIFUL BLACK INSTITUTION.

POETS SHOULD WRITE SONGS.

And so on. Back to Albert. The so-called New Music represents at the core of its emanations the philosophical search of Black people for Self-Definition. Unlike the blues, its placement is more directed at our possibilities in the cosmic sense. Every aspect of the music can feed on the other. There are still a myriad of possibilities for musicians in the area of the human voice. Max Roach and Donald Byrd showed the way; and there is still a lot of space left as Coltrane, Pharoah, and Albert indicate.

There are some profound possibilities in the area of the tribal chorus. (Check out volume two of the *World*

Library of Folk and Primitive Music, Columbia, KL-205.)
But these possibilities, as relevant as they are, will not
be realized if we approach them as gimmicks adopted
from jive white boys. What we will get in that case will
be bullshit "universalism."

Albert you are already universal. You were universal
when you cut *My Name Is Albert Ayler*; and even there
the context was bad. Swedish nightmares. If you speak
to your Brothers and Sisters, to us who really love and
care not just for you but for us, you will be in fact uni-
versal. Check out your context Black musicians. Who is
your *primary* audience? Ed Sullivan, Janis Joplin, Tim-
othy Leary ... ? Or are you about something that relates
to us; and even though we be slow in digging you some-
times, just the fact of you being nearby, around the cor-
ner; we all working it out together, reaching for that Unity
Form; just this fact alone deepens communication and
strengthens in a concrete spiritual manner.

GREAT SPIRITS, HELP US TO SEE AND HEAR
ASANTE

Some Reflections on the Black Aesthetic
The Black Aesthetic, edited by Addison Gayle Jr. (1971)

This outline below is a rough overview of some categories and elements that constituted a "Black Aesthetic" outlook. All of these categories need further elaboration, so I am working on a larger essay that will tie them all together.

1. RACE MEMORY (Africa, Middle Passage)
 Rhythm as an expression of race memory; rhythm as a basic creative principle; rhythm as a existence, creative force as vector of existence. Swinging

2. MIDDLE PASSAGE (Diaspora)
 Race memory: terror, landlessness, claustrophobia: "America is a prison …" Malcolm X.

formal manifestation
Samba, Calypso
Batucada, Cha-Cha,
juba, gospel songs,
jubilees, work song,
spirituals.

Mythology
Spirit worship,
Orishas, ancestors,
African Gods.
Syncretism/
Catholic voodoo,
macumba, Holy Ghost,
Jesus as somebody
you might know, like
a personal deity.
River spirits.

3. TRANSMUTATION AND SYNTHESIS
Funky Butt, Stomps, Jump Jim Crow,
Buck 'n' Wing, Jigs, Snake, Grind,
slow drag, jitterbug, twist, Watusi,
fish, swim, Boogaloo, etc. Dance to
the *after* beat. Dance as race memory;
transmitted through the collective
folk consciousness.

formal manifestation
All aspects of Black
dance styles in the
New World. Pelvic.
Dress and walk.

Neo-Mythology
Shamans: Preachers,
poets, blues singers,
musicians, mackdaddies,
and politicians.

4. BLUES GOD/TONE AS MEANING
AND MEMORY
Sound as racial memory, primeval. Life
breath. Word is perceived as energy or
force. Call and response Blues perceived
as an emanation outside of man, but yet
a manifestation of his being/reality.

Neo-Mythology
Legba, Oshun,
Yemaya, Urzulie,
Soul Momma, Evil
women, Good loving
women, women as primarily

need/man as doer. Blues singer as poet and moral judge; bad man Earth centered, but directed cosmologically. Folk poet, philosopher, priest, priestess, conjurer, preacher, teacher, hustler, seer, soothsayer …

Same energy source as Gospel, field holler, but delineated in narrative song. The African voice transplanted. This God must be the meanest and the strongest. He survives and persists. Once perceived as an evil force:

"and I (Dude Botley) got to thinking about how many thousands of people (Buddy) Bolden had made happy and all of them women who used to idolize him. 'Where are they now?' I say to myself. Then I hear Bolden's cornet. I look through the crack and there he is, relaxed back in the chair, blowing that silver cornet softly, just above a whisper, and I see he's got his hat over the bell of the horn. I put my ear close to the keyhole. I thought I

heard Bolden play the blues before, and play hymns at funerals, but what he is playing now is real strange and I listen carefully, because he's playing something that, for a while sounds like the blues, then like a hymn. I cannot make out the tune, but after a while I catch on. He is mixing up the blues with the hymns. He plays the blues real sad and the hymn sadder than the blues and then the blues sadder than the hymn. That is the first time that I had ever heard hymns and blues cooked up together. A strange cold feeling comes over me; I get sort of scared because I know the Lord don't like that mixing the Devil's music with his music … It sounded like a battle between the Good Lord and the

Devil. Something tells me to listen and see who wins. If Bolden stops on the hymn, the Good Lord wins; if he stops on the blues, the Devil wins."

HISTORY AS UNITARY MYTH
Shango, Nat Turner, Denmark Vesey, Br'er Rabbit, High John the Conqueror, Jack Johnson, Ray Robinson, Signifying Monkey, Malcolm X, Adam Clayton Powell, Garvey, DuBois, Hon. Elijah Muhammad, Martin L. King, Rap Brown, Rev. Franklin, Charlie Parker, Duke Ellington,

5. BLACK ARTS MOVEMENT/BLACK ART AESTHETIC
Feeling/contemporary and historical. Energy intensifies. Non-matrixed art forms: Coltrane, Ornette, Sun Ra. More concerned with the vibrations of the Word, than with the Word itself. Like signifying.
The Black Nation as Poem. Ethical stance as aesthetic. The synthesis of the above presented outline. The integral unity of culture, politics, and art. Spiritual.

James Brown, Bessie Smith, Moms Mabley, King Pleasure, Raefilt Johnson. Son House. Louis Armstrong … Voodoo again/Ishmael Reed's Hoodoo. Islamic Sufis. Third World's destiny. The East as the Womb and the Tomb. Fanon's Third World, Bandung Humanism. Revolution is the operational mythology. Symbol change. Expanded metaphors as in the poetry of Curtis Lyle and Stanley Crouch; or L. Barrett's *Song For Mumu* … Nigger styles and masks such as Rinehart in the

Despises alienation in the European sense. Art consciously committed; art addressed primarily to Black and Third World people. Black attempts to realize the world as art by making Man more compatible to it and it more compatible to Man. Styles itself from nigger rhythms to cosmic sensibility. Black love, conscious and affirmed. Change.

Invisible Man. Style as in James P. Johnson description of stride pianists in the twenties. Bobby Blue Bland wearing a dashiki and a process. All of this links up with the transmutation of African styles and the revitalization of these styles on the West.

Introduction
Dust Tracks on a Road, Zora Neale Hurston (1971)

Writing in the May 1928 edition of *The World Tomorrow*, Zora Neale Hurston made the following observation about herself: "Sometimes, I feel discriminated against, but it does not make me angry. It merely astonishes me. How can anyone deny themselves the pleasure of my company!" This is the kind of remark that one came to expect from Miss Hurston, who is remembered as one of the most publicly flamboyant personalities of the Harlem literary movement. She was very bold and outspoken—an attractive woman who had learned how to survive with native wit. She approached life as a series of encounters and challenges; most of these she overcame without succumbing to the maudlin bitterness of many of her contemporaries.

In her autobiography, *Dust Tracks on a Road*, she explains her life as a series of migrations, of wanderings, the first of these beginning with the death of her mother. She then went to live with various relatives, who very often could not relate to her fantasy-oriented approach to life. As a child, she nearly lived inside of books. She may have been something of a show-off, and this would have probably annoyed her relatives, who were hardworking people and therefore concerned with the more fundamental aspects of life. They found her a somewhat difficult child to rear, and consequently, she was shifted back and forth among them.

Although she was totally dependent upon them for survival, she refused to humble herself to them:

A child in my place ought to realize I was lucky to have a roof over my head and anything to eat at all. And from their point of view, they were right. From mine, my stomach pains were the least of my sufferings. I wanted what they could not conceive of. I could not reveal myself for lack of expression, and then for lack of hope of understanding, even if I could have found the words. I was not comfortable to have around. Strange things must have looked out of my eyes like Lazarus after his resurrection.

She was fourteen years old when she began taking jobs as a maid. Several of these jobs ended in disappointment. She was in a difficult position. She was a Southern Black child who was forced by economic necessity to make a living. But if given a choice between performing her duties as a maid or reading a book from the library of an employer, she almost always chose reading the book. She describes this period of her life as "restless" and "unstable."

But she was finally fortunate enough to acquire a position as maid to an actress. This position represents a significant break from the parochialism of her rural background and opens the way for her entry into creative activity as a way of life. Here, at last, she could exploit her fantasies. Here she could be the entertainer and the

entertained. And most important, for this small-town Black Southerner, she could travel and seriously begin to bring some shape to her vagabond existence.

Black people have almost boundless faith in the efficacy of education. Traditionally, it has represented the chief means of overcoming the adversities of slavery; it is the group's main index of concrete achievement. Zora shared the group's attitude toward education. It represents a central motif all throughout her autobiography. Education, for her, became something of a grail-like quest. No sooner was she situated in a school than she would have to leave in order to seek employment, usually as a maid, sometimes as a babysitter. But her life experiences and her reading were an education in themselves. By the time she entered Morgan College in Baltimore, she was sophisticated, in a homey sort of way, and tough. She had personality, an open manner that disarmed all those who came in touch with her. But none of this would have meant anything if she had been without talent.

After a short stay at Morgan College, she was given a recommendation to Howard University in Washington, DC. There, she soon came under the influence of Lorenzo Dow Turner, head of the English department. He was a significant influence, one of those unsung heroes of Afro-American scholarship, the author of a very significant monograph on African linguistic features in Afro-American speech. It was while Zora was at Howard that she also published her first short story, "Drenched in Light," in *Opportunity*, a magazine edited by Charles

S. Johnson. Her second short story, also published in *Opportunity*, won her an award, a secretarial job with Fannie Hurst, and a scholarship to Barnard. There, she came under the influence of Franz Boas, the renowned anthropologist. It was Boas who suggested that she seriously undertake the study of African American folklore.

Zora Neale Hurston was born in 1901 in the all-Black town of Eatonville, Florida. This town and other places in Florida figure quite prominently in much of her work, especially her fiction. Her South was, however, vastly different from the South depicted in the works of Richard Wright. Wright's fictional landscape was essentially concerned with the psychological ramifications of racial oppression, and Black people's response to it. Zora held a significantly different point of view. For her, in spite of its hardships, the South was Home. It was not a place from which one escaped, but rather the place to which one returned for spiritual revitalization. It was a place where one remembered with fondness and nostalgia the taste of soulfully prepared cuisine. Here one recalled the poetic eloquence of the local preacher (Zora's father had been one). The South also represented, for her, a place with a distinct cultural tradition. Here one heard the best church choirs in the world, and experienced the great expanse of green fields.

When it came to the South, Zora could often be an inveterate romantic. In her work, there are no bellboys shaking in fear before brutal tobacco-chewing crackers. Neither are there any Black men being pursued by lynch

mobs. She was not concerned with these aspects of the Southern reality. It would be unfair to accuse her of escapism; the historical oppression that we now associate with Southern Black life was not a central aspect of her experience.

Perhaps this was because she was a Black woman—rather than a Black man—and therefore not considered a threat to anyone's system of social values. One thing is clear, though: unlike Richard Wright, she was no political radical. She was, instead, a belligerent individualist who was decidedly unpredictable and, perhaps, a little inconsistent. At one moment, she could sound highly nationalistic. Then at other times she might mouth statements which, in terms of the ongoing struggle for Black liberation, were ill conceived and even reactionary.

Needless to say, she was a very complex individual. Her acquaintances ranged from the blues people of the jooks and the turpentine camps in the South to the upper-class literati of New York City. She had been Fannie Hurst's secretary, and Carl Van Vechten was a friend throughout most of her professional career. These friendships were, for the most part, genuine, even if they do somewhat smack of opportunism on Zora's part. For it was the Van Vechtens and the Nancy Cunard types who exerted a tremendous amount of power over the Harlem literary movement. For this element, and others, Zora appears to have become something of a cultural showcase. They clearly enjoyed her company, and often "repaid" her by bestowing all kinds of favors upon her.

In this connection, one of the most interesting depictions of her is found in Langston Hughes's autobiography, *The Big Sea*:

> In her youth, she was always getting scholarships and things from wealthy white people, some of whom simply paid her just to sit around and represent the Negro race for them; she did it in such a racy fashion. She was full of side-splitting anecdotes, humorous tales, and tragicomic stories, remembered out of her life in the South as the daughter of a travelling minister of God. She could make you laugh one minute and cry the next. To many of her white friends, no doubt, she was a perfect "darkie," in the nice meaning they give the term—that is, a naïve, childlike, sweet, humorous, and highly colored Negro.

According to Mr. Hughes, she was also an intelligent person who was clever enough never to allow her college education to alienate her from the folk culture which became the central impulse in her life's work.

Significantly, it was in the field of folklore that she did probably her most commendable work. With the possible exception of Sterling Brown, she was the only important writer of the Harlem literary movement to undertake a systematic study of African American folklore. The movement had as one of its stated goals the re-evaluation of African American history and folk culture, but there appears to have been very little work done in

these areas by the Harlem literati. Although there was a general awareness of the literary possibilities of Black folk culture—witness the blues poetry of Langston Hughes and Sterling Brown—generally speaking, very few writers of the period committed themselves to intensive research and collection of folk materials. (This is especially ironic given the particular race consciousness of the twenties and thirties.)

Thus, vital areas of folkloristic scholarship went unexplored. What this means, in retrospect, is that the development of a truly original literature would be delayed *until Black writers came to grips with the cultural ramifications of the African presence in America.* Because Black literature would have to be, in essence, the most profound, the most intensely human expression of the *ethos* of a people. This literature would realize its limitless possibilities only after creative writers had come to some kind of understanding of the specific as well as the general ingredients that must enter into the shaping of an African culture in America. In order to do this, it would be necessary to establish some new categories of perception; new ways of seeing a culture which had been caricatured by the white minstrel tradition, made hokey and sentimental by the nineteenth-century local colorists, debased by the dialect poets, and finally made a "primitive" aphrodisiac by the new sexualism of the twenties.

And to further complicate matters, the writer would have to grapple with the full range of literary technique

and innovation which the English language had produced. Content and integrity of feeling aside, much of the writing of the so-called Harlem Renaissance was a pale reflection of outmoded conventional literary technique. Therefore, the Harlem literary movement failed in two essential categories: *form* and *sensibility*. Form relates to the manner in which literary technique is executed; while sensibility, as used here, pertains to the cluster of psychological, emotional, and psychic states which have their basis in mythology and folklore. In other words, we are talking about the projection of an *ethos* through literature; the projection of the *characteristic* sensibility of a nation or of a specific sociocultural group.

In terms of the consummate uses of the folk sensibility, the Harlem movement leaves much to be desired. There was really no encounter, or subsequent grappling with, the visceral elements of the Black Experience, but rather a tendency on the part of many of the movement's writers to pander to the voguish concerns of the white social circles in which they found themselves.

But Zora's interest in folklore gave her a slight edge on some of her contemporaries. Her first novel, *Jonah's Gourd Vine* (1934), is dominated by a gospel-like feeling. It is somewhat marred by its awkward use of folk dialect, but in spite of this, she manages to capture, to a significant extent, the inner reality of a religious man who is incapable of resisting the enticements of the world of flesh. She had always maintained that the Black preacher was essentially a poet; in fact, the only true poet to which the

race could lay claim. In a letter to James Weldon Johnson, April 16, 1934, speaking of *Jonah's Gourd Vine*, she wrote:

> I have tried to present a Negro preacher who is neither funny nor an imitation Puritan ram-rod in pants. Just the human being and poet that he must be to succeed in a Negro pulpit. I do not speak of those among us who have been tampered with and consequently have gone Presbyterian or Episcopal. I mean the common run of us who love magnificence, beauty, poetry and color so much so that there can never be too much of it.

The poetic aspect of the Black sermon was a central concern of hers around the publication of *Jonah's Gourd Vine*. By then she had begun systematically to study and collect Afro-American folklore, and was especially interested in isolating those features indicating that a unique sensibility was at work in African American folk expression. In this connection, she wrote an essay for Nancy Cunard's *Negro Anthology* (1934) entitled "Characteristics of Negro Expression." A rather lightweight piece, really. But it is important because it does illustrate one significant characteristic of African-derived cultures: the principle of "acting out." She writes, "Every phase of Negro life is highly dramatized. No matter how joyful or how sad the case there is sufficient poise for drama. Everything is acted out." She saw the Black preacher as the principal dramatic figure in the socioreligious lives of Black people.

Commenting to James Weldon Johnson on a *New York Times* review of *Jonah's Gourd Vine*, she complains that the reviewer failed to understand how the preacher in her novel "could have so much poetry in him." In this letter of May 8, 1934, she writes:

> When you and I (who seem to be the only ones even among Negros who recognize the barbaric poetry in their sermons) know that there are hundreds of preachers who are equalling that sermon [the one in *Jonah's Gourd Vine*] weekly. He does not know that merely being a good man is not enough to hold a Negro preacher in an important charge. He must also be an artist. He must be both a poet and an actor of a very high order, and then he must have the voice and figure.

Her second novel, *Their Eyes Were Watching God* (1937), is clearly her best. This work indicates that she had a rather remarkable understanding of a blues aesthetic and its accompanying sensibility. To paraphrase Ralph Ellison's definition of the blues, this novel confronts the most intimate and brutal aspects of personal catastrophe and renders them lyrically. She is inside of a distinct emotional environment here. This is a passionate, somewhat ironic love story—perhaps a little too rushed in parts—but written with a great deal of sensitivity to character and locale.

In *Moses, Man of the Mountain* (1939), she retells the story of the biblical Moses. Naturally, she attempts to

overlay it with a Black idiom. She makes Moses a hoodoo man with African-derived magical powers. She is apparently attempting to illustrate a possible parallel between the ancient Hebrew search for a nation and the struggles of Black people in America. This book is not bad either, but who could go wrong using such epic material as a framework for a novel?

The Bible had always been of special importance to her. It was the first book she read seriously. And, of course, the Bible is usually the most prominent piece of literature in the homes of most Black families, especially in the South. In fact, the title *Jonah's Gourd Vine* comes from the Bible. In a letter to Carl Van Vechten, she explains: "You see the prophet of God sat up under a gourd vine that had grown up in one night. But a cut worm came along and cut it down. One act of malice and it is withered and gone. The book of a thousand million leaves was closed."

And finally, in further correspondence to Carl Van Vechten, she expresses a desire to write another novel on the Jews. This one was to be of immense scope. It was to be based on the premise that Moses and the Levites were actually oppressors of the Jews, and not necessarily their liberators. She notes, for example, that these "oppressors" forbade the writing of other books, so that in three thousand years, only twenty-two books of the Bible were written. The novel was never published, but its working title was "Under Fire and Cloud."

Her last published novel is a sometimes turgid romance entitled *Seraph on the Suwanee* (1948). Its central

characters are white Southerners. It is competently written but has no compelling significance. She was often in need of money, and she may have intended it as a better-than-average potboiler.

She made her most significant contribution to Black literature in the field of folkloristic research. *Mules and Men* (1935) is a collection of African American folktales; it also gives a vivid account of the practice of hoodoo in Louisiana. *Tell My Horse* (1938), a book about Jamaican and Haitian culture, is perhaps one of the most important accounts of voodoo rites and practices in print anywhere. It successfully competes with most of the books on the subject, and there are quite a few of them.

An interesting aspect of both of these books, especially *Tell My Horse*, is the way she completely immerses herself in whatever kind of sociocultural event she is trying to understand. Both in Louisiana and Haiti, she allowed herself to be initiated into the various rites she was studying, repeatedly submitting herself to the rigorous demands of the "two-headed" hoodoo doctors of New Orleans and the voodoo *houngans* of Haiti. Although an excellent observer of the folkloristic and ritualistic processes, she approached her subject with the engaged sensibility of the artist, essentially freewheeling and activist, and would have been very uncomfortable as a scholar committed to "pure research." She left the "comprehensive" scientific approach to culture to men like Franz Boas, her former teacher, and Melville Herskovits.

Her autobiography, *Dust Tracks on a Road*, helps to give us a fundamental sense of the emotional tenor of her life. It was a life full of restless energy and movement. It was a somewhat controversial life in many respects. For she was not above commercial popularization of Black culture. And many of her contemporaries considered her a pseudo-folksy exhibitionist or, worse, a Sol Hurok of Black culture. One elderly Harlem writer recalls that, at a party she gave for both white and Negro friends, she was said to have worn a red bandanna (Aunt Jemima style), while serving her guests something like collard greens and pigs' feet. The incident may be apocryphal. Many incidents surrounding the lives of famous people are. But the very existence of such tales illustrates something central to a person's character. Zora was a kind of Pearl Bailey of the literary world. If you can dig the connection.

As we have already stated, she was no political radical. To be more precise, she was something of a conservative in her political outlook. She unquestionably believed in the efficacy of American democracy, even when that democracy came under very serious critical attack from the white and Black Left of the twenties and thirties. Her conservatism was composed of a naive blend of honesty and boldness. She was not above voicing opinions that ran counter to the prevailing thrust of the civil rights movement. For example, she was against the Supreme Court decision of 1954. She felt that the decision implied a lack of competency on the part of Black

teachers; and hence, she saw it as essentially an insult to Black people.

After a fairly successful career as a writer, she suddenly dropped out of the creative scene after 1948. Why she did this is something of an enigma. She was at the apex of her career. Her novel *Seraph on the Suwanee* had received rather favorable reviews, and her letters to Carl Van Vechten indicate that she had a whole host of creative ideas kicking around inside of her.

Perhaps the answer lies in an incident that occurred in the fall of 1948: she was indicted on a morals charge. The indictment charged that she had been a party in sexual relationships with two mentally ill boys and an older man. The charge was lodged by the mother of the boys. All the evidence indicates that the charge was false, since Zora was out of the country at the time of the alleged crime; but several of the Negro newspapers exploded it into a major scandal. Naturally, Zora was hurt, and the incident plunged her into a state of abject despair. She was proud of America and extremely patriotic. She believed that even though there were some obvious faults in the American system of government, they were minimal; or at worst, the aberrations of a few sick, unrepresentative individuals. This incident made her question the essential morality of the American legal system.

In a letter to her friend Carl Van Vechten she wrote:

I care for nothing anymore. My country has failed me utterly. My race has seen fit to destroy me without

reason, and with the vilest tools conceived of by man so far. A society, eminently Christian, and supposedly devoted to super decency has gone so far from its announced purpose, not to *protect* children, but to exploit the gruesome fancies of a pathological case and do this thing to human decency. Please do not forget that thing was not done in the South, but in the so-called liberal North. Where shall I look in the country for justice.... All that I have tried to do has proved useless. All that I have believed in has failed me. I have resolved to die. It will take me a few days to set my affairs in order, then I will go.

There was no trial. The charges were dropped. But Zora Neale Hurston ceased to be a creative writer, although in the early fifties she had articles accepted by *The Saturday Evening Post* and the conservative *American Legion Magazine*. She took a job as a maid, and after the appearance of her article in the *Post*, her employers discovered her true background and told all their friends. Stories later appeared in many newspapers around the country, telling of the successful Negro writer who was now doing housework. A story in the *St. Louis Post-Dispatch* quoted her as saying: "You can use your mind only so long.... Then you have to use your hands. It's just the natural thing. I was born with a skillet in my hands. Why shouldn't I do it for somebody else a while? A writer has to stop writing every now and then and live a little. You know what I mean?" James Lyons, the reporter

who wrote the story, went on to say: "Miss Hurston believes she is temporarily 'written out.' An eighth novel and three new short stories are now in the hands of her agents and she feels it would be sensible to 'shift gears' for a few months."

But none of her plans ever materialized. Zora Neale Hurston died penniless on January 28, 1960, in the South she loved so much.

Foreword
Baraka: The Renegade and the Mask, Kimberly W. Benston
(1976)

This is a very tough book. It is the first really important
study of the literature and cultural criticism of the con-
troversial Black American poet, Imamu Baraka. Kim-
berly Benston has intentionally eschewed the more
overtly sensational aspects of Baraka's career. Instead, he
has attempted the systemic exploration of Baraka's liter-
ary themes and the attitudes toward culture that inform
them. This is not journalistic sociology masquerading as
literary criticism. Essentially, Benston has avoided the
sociological trap which often ensnares Black and white
critics of Afro-American literature and culture.

An understanding of Baraka's work demands the
analytical intelligence associated with modern critical
technique, but it also demands something more, some-
thing beyond rhetorical display. That "something" we
designate the "Black Ethos." There are quotation marks
around this because we must keep in mind Albert Mur-
ray's stipulation that sometimes black is not really black,
and white is not really white. But Murray would probably
agree that there is a specific texture to Black American
life and culture. In framing his study, Benston has kept
this in mind. He not only locates Baraka in the general
tradition of modern literature, but he also understands
the compelling significance of the poet's specific cultural
references. Benston has done an especially good job in

exploring the links between Baraka's aesthetic and Afro-American music. This is extremely important, because Afro-American music has been a major internal force in the shaping of Afro-American culture and literary styles.

No serious critic can begin to grapple with the Black Ethos unless he first comes to grips with the psychic vortex, the emotional and mythic history that operates in the subtext of the poet's aesthetic. For example, in the works of Baraka and many other writers in the sixties—notably, Ishmael Reed, Askia M. Touré, and Henry Dumas—there is an awesome "double consciousness" of the dominant society. In their cosmologies America and the European idea which birthed her are at once objects of disdain and admiration.

The Black poet sets forth like the storybook hero to engage in what George Kent terms the "Adventure of Western Culture." He learns the structure of Western thought and the Western terms in which the world is ordered. If he is lucky enough to receive a university education, and if he is interested in ideas, he literally inundates himself in the whole of Western culture. He passionately encounters the works of Dante, Goethe, Heine, Marx, Wittgenstein, Joyce, Beckett, Sartre, Pound, ad infinitum. And out of this encounter, which is, in fact, an encounter with tradition, the poet must fashion *his own* artistic image, his special ethos. He must, as the nameless narrator of Ellison's *Invisible Man* perceives, shape the "uncreated features of his face."

For some writers in the Black diaspora the adventure led to a spiritual crisis. This is nothing new per se: all of the major explosions and innovations in so-called avant-garde art have taken place around a core of aesthetic and political crisis. What is new, however, is the particular manner in which the diasporic sensibility manifested itself within the Afro-American consciousness. Undoubtedly, the modern Black writer's first problem centered on the issue of language and appropriate form. The distant but gnawing memory of a prior history before the enslavement and the dispersal demanded that he assume a special position with reference to Western language and culture. In the sixties, the Black activist/artist found himself engaged in a cultural revolution whose goal was the reclamation of authentic Black cultures and the development of new aesthetic styles and values.

For many of the poets, this meant that so-called Western values had to be discarded. They declared that at the center of the Western cultural ethos there was a paralysis of the spirit, an atmosphere of decay and malaise which they loathed to embrace.

Perhaps, in this sense, they had really become Western men, the new Rousseaus and Rimbauds in search of Eden. And perhaps, too, they were Western men in that they had fixed their place in history—a possibility that both fascinated and angered them.

And what of history? Had not the West, some of them reasoned, literally invented History and then sallied forth to wield this invention like a weapon before the dis-

possessed of the Earth? This kind of questioning almost invariably forces a shift in perspective, a sense of having arrived at a disjuncture in the adventure. The West is seen as an arhythmical place preoccupied with death. (Recall Ling, Malraux's Chinese visitor to Europe in *The Temptation of the West*, remarking: "You have weighted the universe with anguish.") Wouldn't a fall outside of "history" really be, in fact, a fall outside of the Western idea of order? Isn't that what Tod Clifton in *Invisible Man* finally realizes? Ling or Clifton could symbolize any of the young displaced Negritude poets in Paris during the thirties: Césaire, Senghor, Damas. The adventurer has suddenly become the stranded alien in a strange land.

We have entered a highly charged zone here. Now the poet finds himself foraging among the ruins of his diasporic past. He feels trapped by European culture. He even doubts whether the language in which he expresses his dilemma can ever, finally, sustain the force of his vision. And the very act of doubting takes on the quality of a lucid irrationality. For he may write elaborate treatises in impeccable French or English, denouncing the language of his oppressors, while he asserts the necessity for a new poetic symbology. He is both native and alien. He may be the displaced Jamaican poet in London or the Martinican writer in Paris. He may be the Afro-American poet situated in the United States where he experiences a sense of what scholar Mae Henderson calls "interior exile." The poet is both urban and urbane now. He quotes Pound, but he finally fears—the way only a poet fears—

that he will lose the ability to sing the old songs and do the old dances. He dreads, in short, what T. S. Eliot called "the disassociation of sensibility."

This is the emotional atmosphere in which the search for the Holy Grail of "Blackness" ensues—"spirit," rhythm, and song pitted against "logic" and technology. Hipness pitted against corniness. The idiom of Charlie Parker poised against that of Glenn Miller. The suppleness and the inventiveness of Black popular dance contrasted with the stiffness that seems to abound in the white community. The poet seeks Blackness/Negritude, the élan vital, the primeval and archetypal energy that seems manifest in what Janheinz Jahn called the "neo-African" cultures of the Western hemisphere. There is clearly a Herderian construct operating at the base of the Black aesthetic ideology, but that finally is not important. Consider instead the idea of Blackness as a mythic construct with a nearly discrete cosmology, like the structures of Bantu or Dogon philosophy, or the phenomenology of the blues—a discrete cosmology with its own style, laws, and correspondences. Ishmael Reed's hoodoo novel *Mumbo Jumbo* comes to mind readily. There is nothing impenetrable about it, just as there is nothing truly impenetrable about a work like *Finnegans Wake* once we grasp its overall system and structure.

Much of Baraka's later work strives for a non-Western symbology and mythos. Like Ishmael Reed and Henry Dumas, he evokes the orishas and loas of the Yoruba and Haitian pantheons. He also tries to modulate the pull of

Western culture by undertaking the study of Sanskrit, Arabic, Swahili, Amharic. He consciously attempts to create a mythology out of the symbols of a pre-Christian, non-European past—a past dominated by what the poet feels to be a more liberating and vibrant sensibility. So our adventurer in the Western realms of gold forays Southward toward the Sun and the place of rhythm:

> We are beautiful people
> with african imaginations
> full of masks and dances and swelling chants
> with african eyes, and noses, and arms,
> though we sprawl in grey chains in a place
> full of winters, when what we want is sun.
> —Imamu Baraka, "Ka 'Ba"

And here, in what Baraka calls the "black labs of the heart," the poet attempts the ritual enactment of his priestly role as artificer and oracle for his community (nation). He has come a long way to get home and still can't be sure whether he has found a real haven or just another kind of illusion. This is the conundrum, the tragic situation that confronts the diasporic artist as he attempts to liberate himself psychically from what he feels to be the death-oriented ethos of the West.

It is in this context that Black music occupies a central place in Black aesthetic ideology and vocabulary. For the music has never had to explain itself; it simply exists in all of its glory. In the churches, the fields, the juke joints,

the chain gangs, and in the Mintons and Savoys, the music had even developed its own craft procedures and critique. It forged a character all its own, and it apologized to no one. A famous musician involved in the so-called bebop movement at Minton's once remarked: "We wasn't giving lectures, we was making music."

It took a long time for Black writers to develop a critical perspective on Afro-American music. After the pioneering efforts of Alain Locke, Sterling Brown, and John Work there was a hiatus in which very little critical work was done on Afro-American music by Blacks themselves. So until Ellison's seminal essays in *Shadow and Act*, Baraka's *Blues People*, and A. B. Spellman's *Four Lives in the Bebop Business*, Afro-American musical criticism was generally left to perceptive white men like Marshall Stearns, André Hodeir, Nat Hentoff, Henry Pleasants, and Ross Russell. But the movement toward cultural awareness forced Black writers to assume more responsibility for a critique of the music and its social implications. It forced them to listen to the music of the people in a new fashion. Ellison led the way with his essay in *Antioch Review* on the blues idiom in Richard Wright; and in a more polemical tone, Baraka's essay "Black Music, White Critic" confronted the question of white dominance in Afro-American musical criticism. Ultimately writers as diverse as James Baldwin and Albert Murray became united in the idea that the music and the dance that accompanied it were the ultimate expressions of the African presence in America.

In his own manner, Kimberly Benston covers most of what I have sketched here.

Baraka: The Renegade and the Mask sets a standard for literary scholarship in this field. Watching Mr. Benston build this study has been a significant educational experience for me. I have learned a great deal, not only about Baraka, but about human will.

LARRY NEAL (1937–1981), a cultural critic, poet, and playwright, was a leading member of the Black Arts Movement, which served as the cultural sister to the Black Power movement in the 1960s and 1970s, calling for self-determination and for Black writers, artists, and musicians to speak directly to the needs, histories, and aspirations of Black America. Born in Atlanta and raised in Philadelphia, Neal studied English and history at Lincoln University in Pennsylvania and took graduate courses in folklore at the University of Pennsylvania before moving to New York in 1964. He and Evelyn Rodgers married in 1966, and their son Avatar was born in 1971. From his base in upper Manhattan, he wrote extensively on art, music, and literature for *Liberator*, where he was the arts editor. He also served as education director of the Black Panther Party, was a member of the Revolutionary Action Movement, and helped build the Black Arts Repertory Theatre in Harlem with the writer and activist Amiri Baraka. In 1968, Neal and Baraka edited *Black Fire: An Anthology of Afro-American Writing*, which would become the defining work of the Black Arts Movement. In 1970, Neal was awarded a Guggenheim Fellowship. He also published two collections of poetry, *Black Boogaloo: Notes on Black Liberation* and *Hoodoo Hollerin' Bebop Ghosts*.

ALLIE BISWAS is a writer and editor based in London. In 2021, she coedited *The Soul of a Nation Reader: Writings by and about Black American Artists, 1960–1980*, a compendium of rarely seen historical texts that address the role of art during the civil rights movement. She has published interviews with artists including Theaster Gates, Rashid Johnson, Julie Mehretu, Meleko Mokgosi, Zanele Muholi, Adam Pendleton, and Wolfgang Tillmans. Her essays have appeared in books on Woody De Othello, Serge Alain Nitegeka, and Reginald Sylvester II, among other artists. Most recently, she has contributed texts to *Portia Zvavahera* (David Zwirner Books, 2023), *Strange Clay: Ceramics in Contemporary Art*, *Hiroshi Sugimoto: Time Machine*, and *Frank Bowling: Sculpture*. She is currently editing a monograph about the artist Hew Locke.

THE *EKPHRASIS* SERIES

"Ekphrasis" is traditionally defined as the literary representation of a work of visual art. One of the oldest forms of writing, it originated in ancient Greece, where it referred to the practice and skill of presenting artworks through vivid, highly detailed accounts. Today, "ekphrasis" is more openly interpreted as one art form, whether it be writing, visual art, music, or film, that is used to define and describe another art form, in order to bring to an audience the experiential and visceral impact of the subject.

The *ekphrasis* series from David Zwirner Books is dedicated to publishing rare, out-of-print, and newly commissioned texts as accessible paperback volumes. It is part of David Zwirner Books's ongoing effort to publish new and surprising pieces of writing on visual culture.

OTHER TITLES IN THE *EKPHRASIS* SERIES

Any Day Now: Toward a Black Aesthetic
Larry Neal

Published by
David Zwirner Books
520 West 20th Street, 2nd Floor
New York, New York 10011
+ 1 212 727 2070
davidzwirnerbooks.com

Editor: Elizabeth Gordon
Editorial coordinator: Jessica
Palinski Hoos
Proofreaders: Victoria Brown,
Janique Vigier

Design: Michael Dyer / Remake
Production manager: Luke Chase
Color separations: VeronaLibri,
Verona
Printing: VeronaLibri, Verona

Typeface: Arnhem
Paper: Holmen Book Cream, 80 gsm

Publication © 2024
David Zwirner Books

Introduction © 2024
Allie Biswas

Texts by Larry Neal © 2024
Larry Neal

p. 5: Larry Neal. Original
photographer and date unknown.
Photo by Stephen Arnold

Our thanks are due to Evelyn Neal,
Marie Brown, and Avatar Neal
for their support and collaboration.
Additional thanks to Erika Moore.

ISBN 978-1-64423-120-3

Library of Congress
Control Number: 2023950502

Printed in Italy